DISCARDED

 W9-BVO-519

751.42
Wood
 Watercolor workshop

14294

DATE DUE

SANTANA HIGH SCHOOL

LIBRARY

9915 Magnolia Avenue
Santee, California 92071

DEMCO—FRESNO

WATERCOLOR WORKSHOP

WATERCOLOR WORKSHOP

BY ROBERT E. WOOD AND MARY CARROLL NELSON

SANTANA HIGH SCHOOL LIBRARY

WATSON-GUPTILL PUBLICATIONS, NEW YORK
PITMAN PUBLISHING, LONDON

Copyright © 1974 by Watson-Guptill Publications

First published 1974 in the United States and Canada by Watson-Guptill Publications,
a division of Billboard Publications, Inc.,
One Astor Plaza, New York, N.Y. 10036

Published in Great Britain by Sir Isaac Pitman & Sons Ltd.,
39 Parker Street, Kingsway, London WC2B 5PB
ISBN 0-273-00859-5

All rights reserved. No part of this publication
may be reproduced or used in any form or by any means—graphic,
electronic, or mechanical, including photocopying, recording, taping,
or information storage and retrieval systems—without
written permission of the publishers.

Manufactured in U.S.A.

Library of Congress Cataloging in Publication Data
Wood, Robert E 1926-
 Watercolor workshop.
 1. Water-color painting—Technique. I. Nelson,
Mary Carroll, joint author. II. Title.
ND2420.W66 751.4'22 74-10938
ISBN 0-8230-5682-1

First Printing, 1974

To those who share my watercolor love

Contents

Acknowledgments

I would like to thank my many students who kept up their endless pressure by asking "When will your book be out?" To Don Holden, Editorial Director of Watson-Guptill Publications, appreciation for his years of patience during my long procrastinations. Without the backing and fine technical writing assistance of Mary Carroll Nelson, my talented co-author, I never would have found the courage to start this project. To my working editors, Diane Casella Hines and Jennifer Place, I wish to state my appreciation for their long hours of behind-the-scenes organization and their understanding in building this book. For their professional help with the bulk of the color photography, I thank Doyle Courington and David Segovia. To Joni, my wife, I give grateful thanks for taking over the chores as my first editor and typist—and for just putting up with me during the months of my isolation in the studio. To my dear mentors, Rex Brandt and Phil Dike, heartfelt thanks for their years of support and encouragement that finally persuaded me to get *Watercolor Workshop* into print.

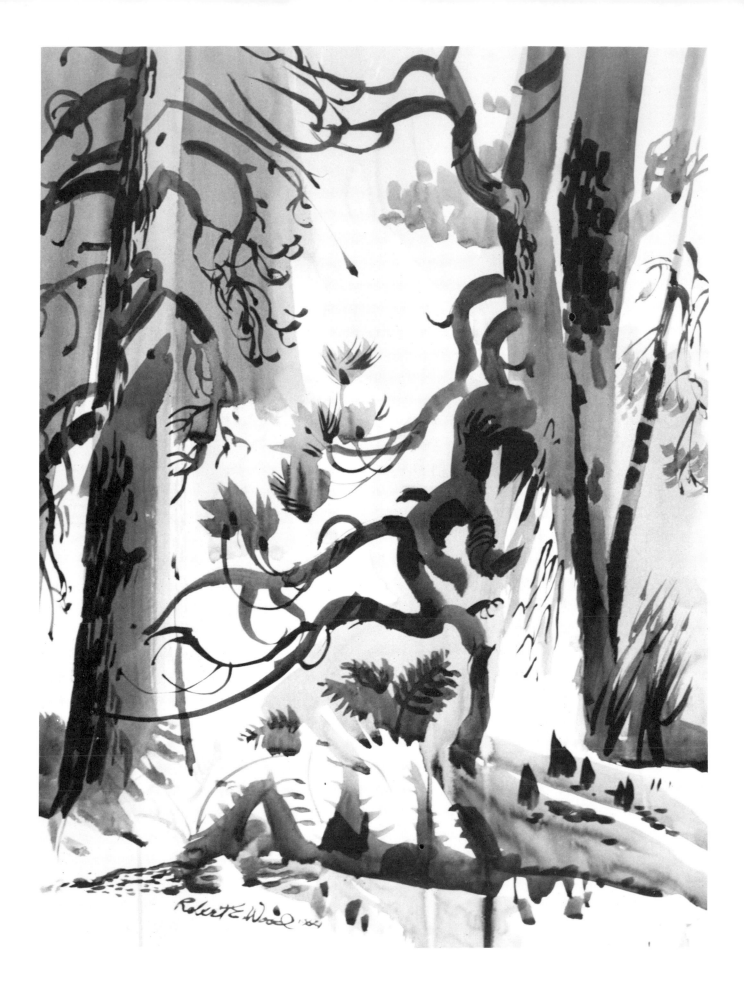

1.

Prepainting Thoughts

Lakeside Trees. *White drawing paper, 18" x 24". I painted this quick study of the character and structure of the trees just below my studio with a limited palette of burnt sienna, phthalo blue, and yellow ochre. I intentionally worked close to the subject to capture the details and stylized character of the scene. I searched for a selective distribution of details and bold accents rather than simply filling the page with overall refinements.*

I've often been asked, "How long did it take you to paint that painting?" My quick reply is, "About three hours and 25 years."

It certainly doesn't take 25 years of preparation to paint a successful watercolor, but more than any other medium, watercolor demands a directness of handling that comes only from constant practice.

The watercolorist is faced with many complex decisions that must be met with authority in a limited amount of time. Basic drawing, composition, color planning, and space and textural controls can all be required simultaneously in the first frantic half-hour of work on a new watercolor.

One type of painting I enjoy doing involves a real battle against time; this happens when I employ the wet-into-wet technique. I start on wet paper, and the basis for the whole painting is laid in while the paper is still damp. Although I can prolong the period of dampness, my best defense is to *plan ahead.* Planning to paint a watercolor often takes longer than the act of painting it.

In this chapter, I want to share my approach to exploring a new subject and the strategy I've developed in my

effort to meet the exciting challenge of watercolor.

Gathering Information

You can only paint what you know. I begin painting the fresh, sparkling watercolors I seek by going to nature for information. I often complete watercolors on location, directly from nature, but I enjoy working in the studio also. Either way, I've found that my chances for completing a well-organized painting improve tremendously if I have some time to get acquainted with the subject—to draw and sketch—before jumping into the final watercolor challenge.

The Sketchbook

For small drawing and painting plans I use 8½" x 11" sketchbooks. In them I gather information from nature. Here is where I answer the question, "What is it?" They're not master drawings, but my personal reactions to a subject. I work in a variety of media: ink, pencil, felt pen, marker, brush, etc., making a collection of notes and observations. These sketchbooks are a storehouse of what I call my vocabulary—those subjects I know well enough to use as source material for future paint-

The Deserted Cabin.
Sketchbook double-page, 11"
x 17". I have sketched and
painted this old cabin near
my studio for years, but I still
find that new excitement
develops from drawing the
area again and again. If I can
do several pages of
informative studies, exploring
new views and altered areas
of emphasis, I find that I can
paint the same old structure
with new involvement and
interesting results.

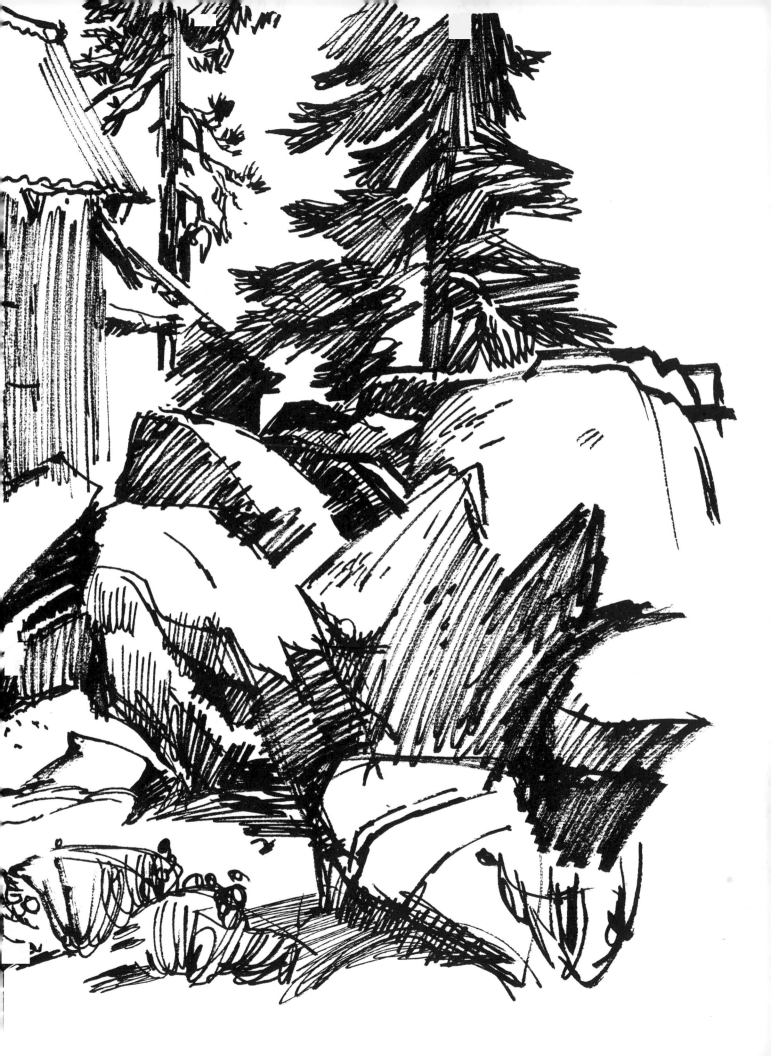

Sketchbooks (Left). 8" x 11". I now have a shelf full of these hardbound sketchbooks that go back more than 15 years. I periodically return to them for "old subjects" to use again in new ways.

Hendricks Head Light (Below). Sketchbook double-page, 11" x 17". Many of my "on location" drawings are truly sketchy and unfinished "notes" to aid in working later watercolors. This study became a finished statement in itself. The pen sketch was done on the spot. I later added the colored washes from memory in the comfort of my studio.

HENDRICKS HEAD LIGHT HOUSE —

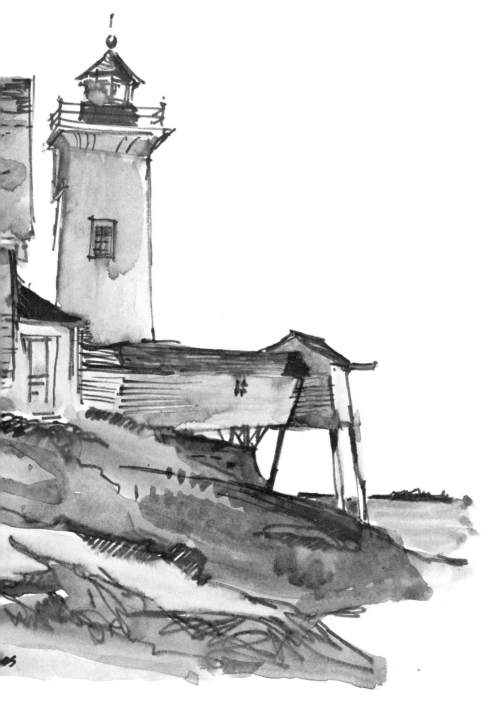

ings. I feel that the practice of sketching and drawing is the fundamental need for the artist.

The portability of the sketchbook is a great advantage. I usually have mine with me, ready for impromptu notes and drawings. However, its relatively small size creates limitations. Ideas recorded on these pages must be "blown up" to grander dimensions when translated into paintings, and this can be a difficult step. I therefore find it useful to also sketch in a full, painting-sized manner in which painting and drawing become one and the same thing.

The Large Brush Drawing

I like to do casual painting-sized brush drawings on inexpensive white studcnt drawing paper, 18″ x 24″. I work directly with paint and brush, and I shy away from a pencil drawing plan that might lead to a stilted "filling in between the lines" attitude. I try to think of shapes, not outlines, while attempting to capture the character of the subject. Complete rendering of all the details doesn't interest me. The drawings are done in a brisk style, a watercolor shorthand. Some of these are drybrush drawings done with little water; others are done in a lush, wet technique. The large paper is important for developing and maintaining mastery of the brush; the aim is to develop bold assurance with the subject before attempting finished paintings. The uninhibited attitude that comes from working directly with expressive watercolor brushes on inexpensive paper leads to a controlled sense of freedom and vitality that I enjoy striving for in my work.

Trees on the Ridge. *Drawing paper, 18" x 24". In this study I used the trees on a distant ridge as my subject. Detail within the trees was therefore less important than the overall changes of the shape and character of the different tree silhouettes. After the large shapes were laid in, I painted into the masses, adding a little development in volume and local color identity.*

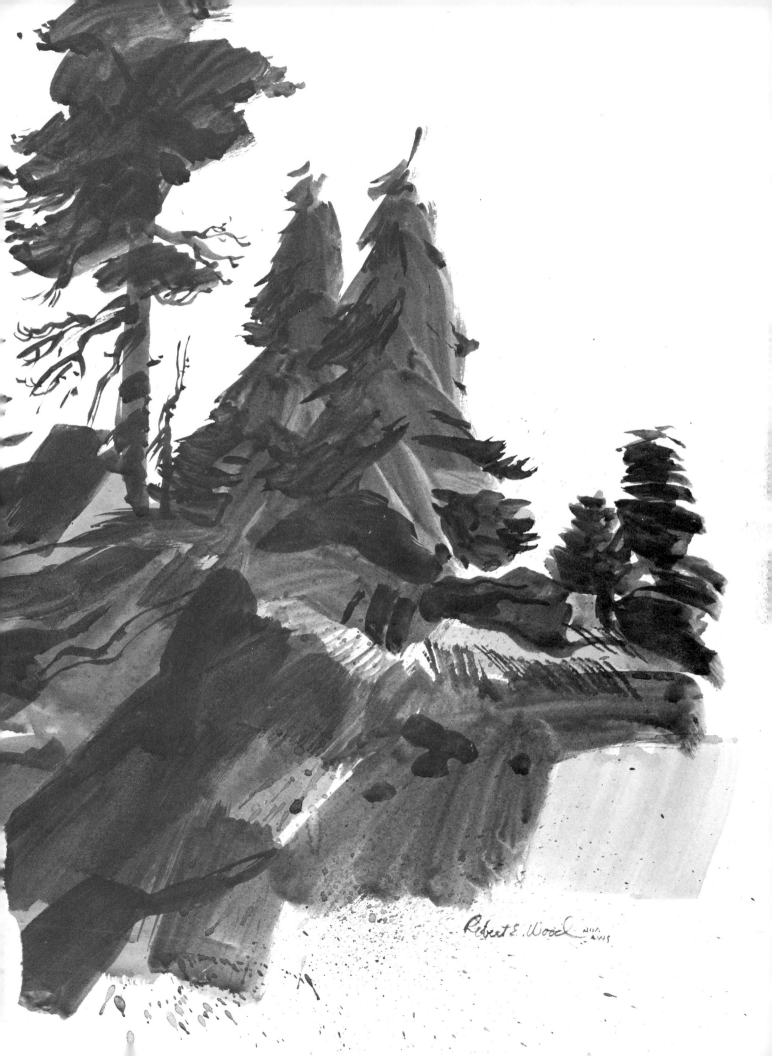

This is still the time for a gathering of information. Although I can appreciate the benefits of doing a careful "in-depth" study, I've found that my time seems better spent doing three or four half-hour searchings than doing a single hour and a half rendering.

My advice to the water-colorist is to first *observe* and *record* your translations of nature in sketchbooks. Second, *practice the subject* in a variety of direct approaches with a brush on large-sized inexpensive paper.

The Abstract in Nature

It takes years of painting and drawing experience to gain a command of the watercolor medium and also to gain the most basic understanding of structure, form, proportion, and perspective. I believe that both self-discipline and instruction will develop the artist's control over his tools and techniques. It seems odd that we must be "taught to see," but it's a fact that the more the artist looks at the complications of subject matter, structure, and design that nature presents, the more he really begins to observe and comprehend. At one point in

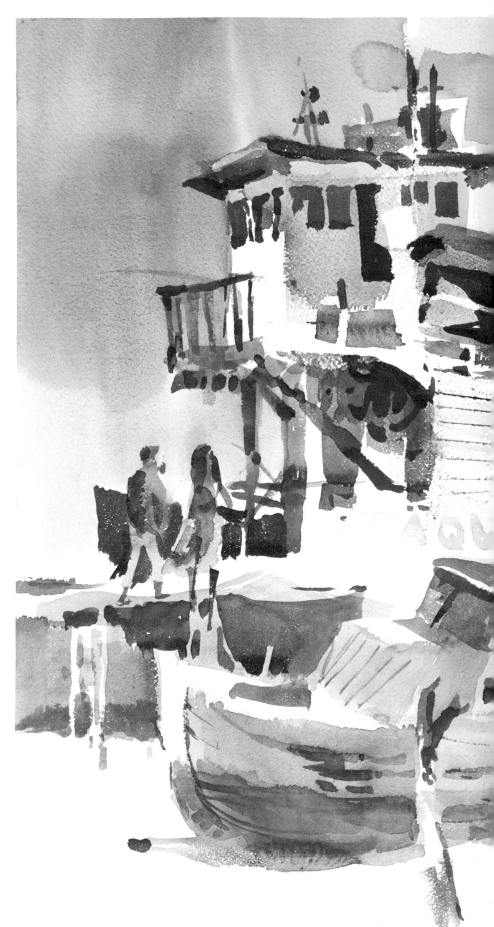

Ferry Boat, Sausalito. D'Arches paper, 22" x 30". This is an example of a "direct drawing" attitude I sometimes enjoy using. Starting with a minimum brush drawing, I painted the shape "abstractions" of the many parts and pieces of this retired ferryboat. I saved a bold amount of white paper and only near the end turned the blazing sunlight on the subject by painting out some good-sized portions of the page with light- and middle-value washes.

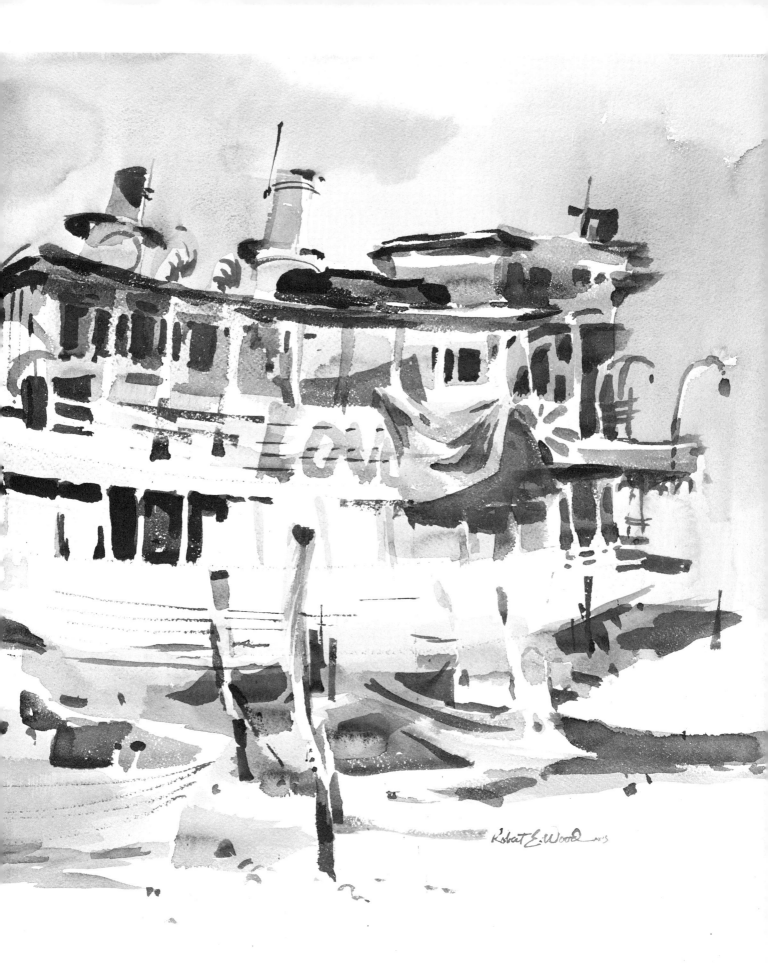

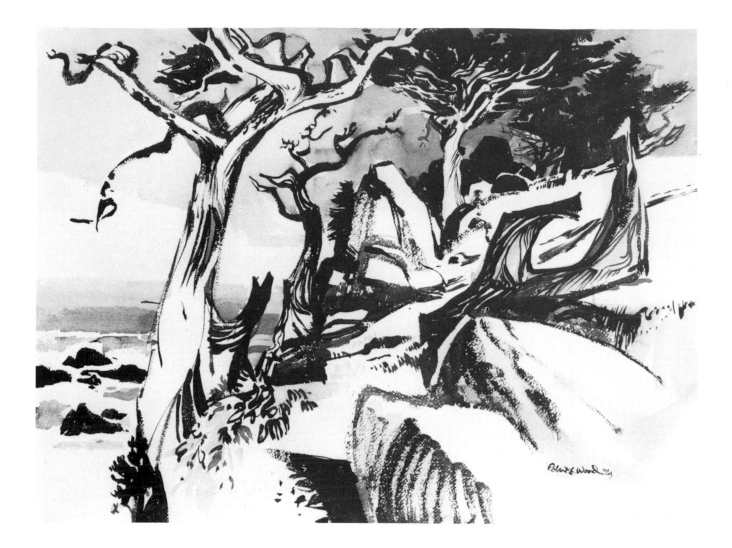

California Coast. D'Arches paper, 22" x 30". *I had painted several watercolors earlier this day on the "17 Mile Drive" near Carmel using conventional techniques, but I felt I had missed the powerful strength of these windblown Monterey pines. This third painting searched out the striking boldness of these tortured giants. I worked directly with a variety of strong darks using both flowing wash accents and drybrush strokes. The supporting light- and middle-value washes were again put in last. Although I was searching the trees, rocks, and sea for their distinctive character, an abstract framework formed the overall design. I attempted to add just enough texture and bold detail to capture the essence of the subject.*

my early studies I remember the valid goal of attempting to simply draw things as they were. Then, after these necessary basic skills were under control, I became aware that I hadn't reached a final goal after all, but had only gathered some of the essential tools for the release of more personally creative ways of working. The search for how to say something suddenly changed to "What am I going to say?" The quest became far more individual—the answers no longer clear-cut, black and white. Fortunately, nature is a great teacher. I constantly return to working directly from the subject, not just for new things to paint, but to search out the abstractions and the unlimited

variety of expressive shapes, patterns, colors, and textures that are always awaiting the inquisitive eye. I try to simplify nature, and because I'm primarily a watercolorist, I've developed ways of seeing and drawing that have a definite possibility of being translated into natural watercolor ways of working. The subject, although not disguised, becomes less important than the overall plan of the presentation. The details are exciting as little abstractions in themselves. Identifying the subject has become much less important than capturing its character. In fact I've found that the character is presented more effectively through the descriptive abstraction of patterns readily found in nature.

The Thumbnail Sketch

After studying nature, the artist must plan the best way to display the subject. This is another time to use the sketchbook. I do many thumbnail compositions in my search for a unique display of space, a satisfying distribution of light and dark, and balance both of mass and complexity. I often try to shift the focus of attention in each new plan. One sketch might be a sky painting plan. Another, a foreground plan or a closeup. One main thought per sketch is enough.

These painting plans can be done with pencil, pen, or brush and wash. I might search out the trial compositions in a linear manner that explores various interesting arrangements of the subject within the picture framework. Other thumbnail studies might be more concerned with value planning (dark and light distribution and balance), done by setting down simple flat tones that preview the organization of the painting's major masses. Doing just one thumbnail plan is practically a waste of time. You might as well work directly on the large painting with this first idea. The benefit of the thumbnail sketch approach becomes evident when, after a series of trial and error variations, one experiment stands forth as being a far more dramatic display than the other. Trial and error explorations of this sort can lead to a painting plan that is unique and interesting instead of just another "so what" composition.

Moonlight on the Cliff. *Sketchbook thumbnails. These small composition plans are examples of the "explorations" that precede the actual painting process. Because I was already familiar with the subject, these small sketches make no attempt to be finished studies in themselves. Instead they become personal notations for possible whole paintings. Mood, scale, space and mass distributions, and the preselection of "saved lights" and "accent areas" are my main concerns.*

Color Studies

The color scheme in a painting can also be preplanned by trying several variations ahead of time. Having settled on a possible composition, I use inexpensive paper to make larger studies, four or more to a sheet.

I try make an inventive, exploratory search to discover an effective color plan. Different color combinations suggest different moods—from low to high key and from solemn to cheerful. Since these quick color studies are in no way precious, I have a wonderful sense of freedom as I explore new uses of color. If one striking color plan emerges from several of these trials, I feel it's well worth the effort. Breaking through the limitations of old habits and entering into new areas of creative involvement can punch new life into paintings.

Technical Decisions

Watercolor offers a range of distinctly different technical effects. The wet-into-wet method of painting on damp paper creates a juicy, diffused softness. Painting on dry paper creates crisp, firm shapes with a hard-edged, in-focus quality. Using drybrush strokes and calligraphy makes for further possible surface qualities. No single formula will satisfy all the needs of the watercolorist. One must fit the technique to the mood. I try to vary my technical approach and not simply paint out of habit.

Examples throughout this book will display the controlled emphasis of one or the other of these technical qualities in different paintings.

Golden Sunset. D'Arches paper, 13" x 20". This painting began with a wet-into-wet underpainting to create a soft, moody effect. Brush calligraphy activates and describes various areas in a bold, scaled manner.

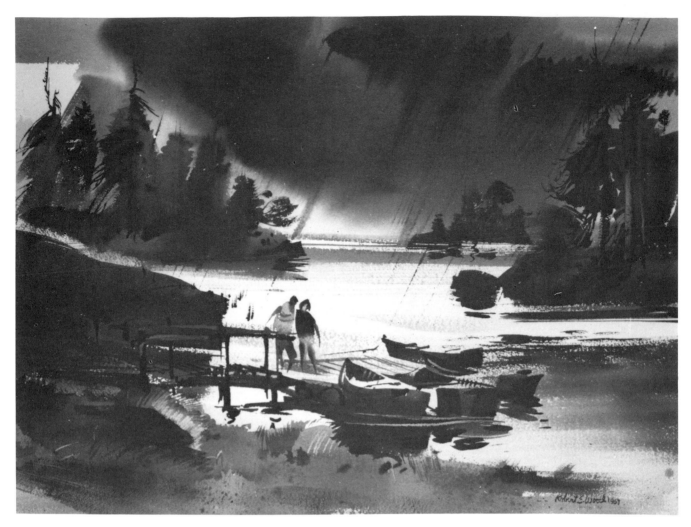

Before the Storm. *D'Arches paper, 22" x 30". My aim in this painting was to stage the scene in a dramatic way. I have pushed the lights. By surrounding them with middle-dark to dark values, attention is focused on the spotlight effect.*

A Mental Plan

I've made recommendations concerning how to prepare yourself for the problems that you'll face when you paint a watercolor. It isn't always possible, or even necessary, to go through the process of sketching, brush drawing, or thumbnails before doing a painting. As I mentioned earlier,"You can only paint what you know," and anything you can do to gain command of your subject and your tools will be highly beneficial to you.

There are times when I'm so enthused about a new subject that I just can't wait to get in there and paint. Many of my "on location" paintings are done on a moment's inspiration. However, I try not to start a new painting blindly. I mentally go through the process of selecting a powerful color plan, deciding on the technique I want to stress, building a composition, and visually examining the subject so I can accurately capture its character. This mental plan of attack can help organize the approach I'll take and set some simple goals to aid in the development of the fresh, direct watercolor statement I strive for. Without this pre-planning I find that final painting is often indecisive or falls apart because it tries to say too much in one picture. I'm not saying that this mental organization ahead of time will guarantee excellent results, but it should help. Actually, it takes far more effort to create a bold simple painting than it does to endlessly "tickle the page to death."

One last word about "the plan." Whether you spend quite a lot of time preparing or just mentally settle upon the ap-

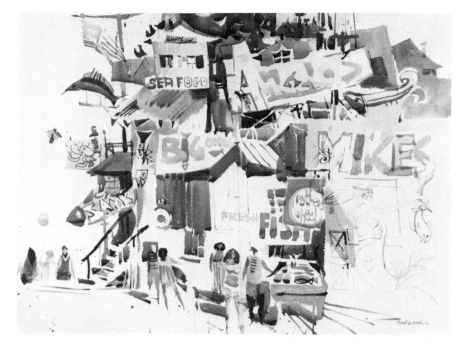

Monterey Signs. *D'Arches paper, 22" x 30". By using a controlled wash on dry paper, I produced hard-edged, crisp shapes to emphasize the structure of this cluttered subject.*

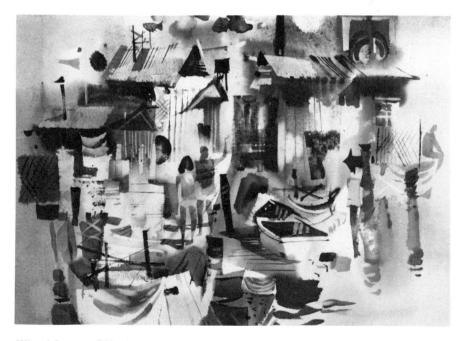

Wharf Space. *D'Arches paper, 22" x 30". In this scene my goal was to make a statement about space. I was not interested in great depth, but used an aerial view and many overlapping objects to pulsate the page with spatial sensations.*

proach you'll take, this plan is only an aid to get you going in a logical direction. Once the painting process has begun don't let the plan block your creativity. It has done the job (a pre-painting job) of setting the limited goals you want to meet this time. While you're actively involved in the painting process trust your senses, your instincts, your past training, and cooperate with the images on the page and the technical results as they emerge. "Go with it." Allow yourself to be involved in the creative struggle. Then when the painting is nearly finished and the major character is established, you can again become more coldly analytical and judge the effectiveness of your efforts. More often than not this is the time I'll say to myself, "Well, at least I learned something from this one," and then jump right in and paint it again.

Valid Reasons to Paint

With a creative approach to painting, the artist may select one quality on which to focus and build his painting. Each painting should have a special character beyond merely reporting on the facts of nature. Exploring some unusual combination of colors might be inspiration enough to start a new version of a subject you're familiar with. Completely different final results might grow out of approaches that stress space or texture or dramatic scale. Adjusting your technique to concentrate on the soft wet-into-wet mood, or conversely, forcing the posterlike, hard-edged firmness of the controlled wash can lead to dramatically different creative statements.

Flame at the Top. D'Arches paper, 22" x 30". This painting stresses crisp decorative patterns and was initiated to explore the brilliant color of the scene.

Painting Value Plans

Many painters progress quite easily to the point where they can paint the objects within a painting sufficiently. The growing problem becomes not, "How can I paint the parts?" but rather, "How can I present an exciting arrangement of the painting as a complete and dramatic unit?" Without expending a great deal of time, I've found it beneficial to do a whole series of smallish value studies that explore these overall arrangements. Since the organization of a good watercolor painting demands a degree of simplification, I try to execute these small studies in a range of only three to five well-staged values. In each plan there are strong, bold value contrasts, not merely outlines. Shapes are kept simple. Balance, scale, and a sense of containment are the goals. By containment, I mean keeping the interest within the painting and not letting it be diverted off the page. In each new plan I try to paint a pleasing gesture. I think of gesture as the directions and rhythms set up in the design by the major shapes and their distribution within the picture framework.

Painting many of these value plans leads to a wide choice of effects from which I can select a favorite plan or two to try in a finished painting.

K.I.S.S. "KEEP IT SIMPLE STUPID"

 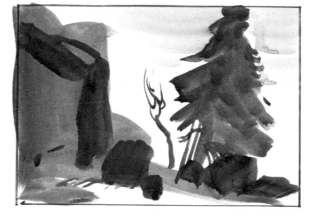

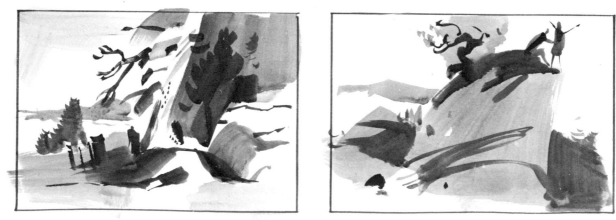

Inspiration Point. Drawing paper, 18" x 24". I have faith that I can paint a rock, a sky, or a tree; consequently, these three-value thumbnails stress the search for a dramatic arrangement of the pictures parts.

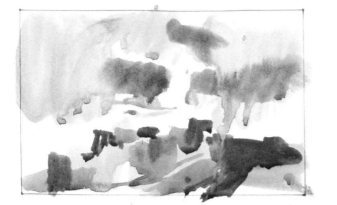

Les Baux. Drawing paper, 18" x 24". This page of 4½" x 7" value plans was done as a "warm up" immediately before doing a full-sheet demonstration for one of my classes. The finished painting that followed was an entirely new creation developed right on the watercolor page, obviously benefiting from the mental preparation achieved while doing the small studies. The subject is medieval mountain-top ruins and a small village in Southern France.

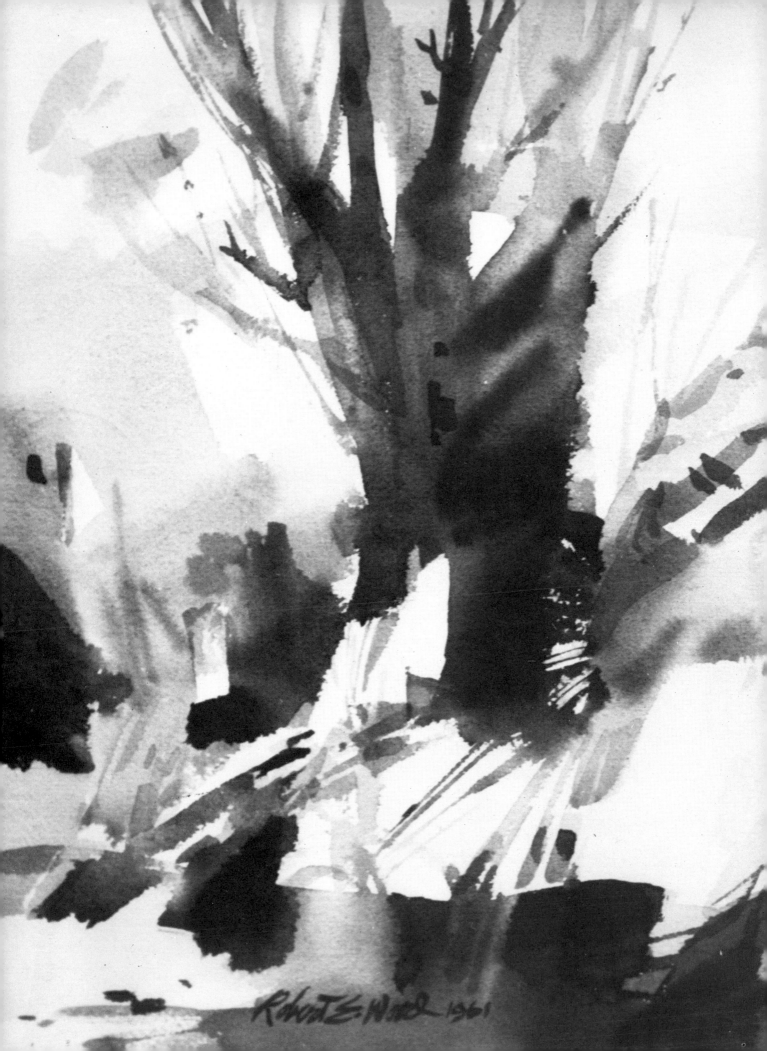

Tree, Snow, and Sky Impressions.
D'Arches paper, 16" x 20". I wanted to make a bold spatial statement in this painting, not just to paint another landscape with trees. It is an abbreviated impression—as abstract as I ever like to work. I find I can paint an authoritative minimum statement only when I know the subject thoroughly; then I'm free to concentrate on other aspects of creative painting.

Boats and Nets, Honfleurs. *D'Arches paper, 13½″ x 20″.*

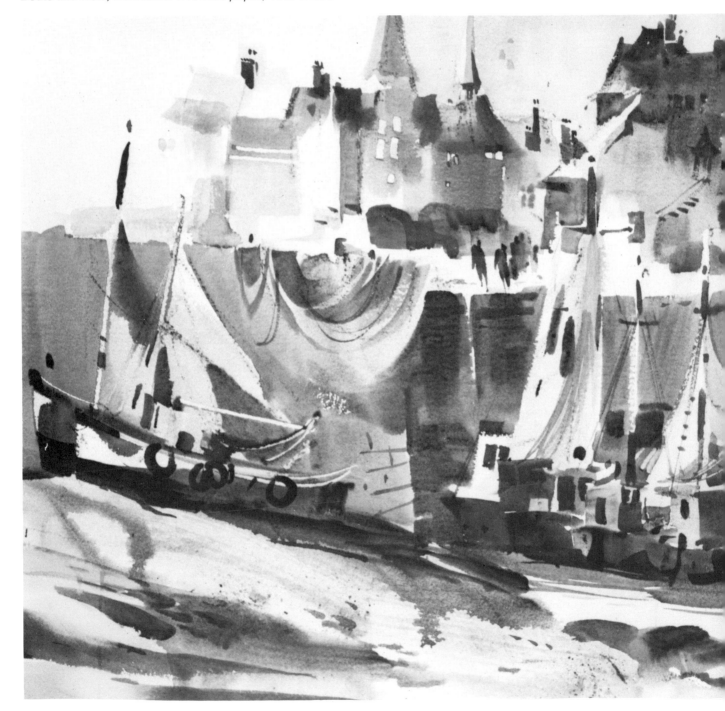

2.

Materials

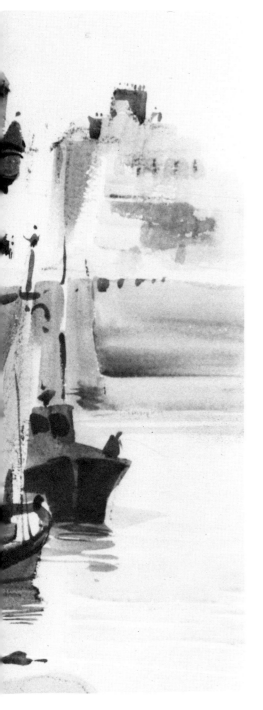

The choice of working equipment for every artist depends on individual preferences and has a lot to do with an artist's methods. Some artists prefer to work large—others work in small format only. Some artists find a limited range of earthy hues satisfying, while others work inventively only with the whole spectrum. Painting on location requires different equipment from painting in the studio.

A full listing of materials available to the contemporary artist would fill a large catalog. I have prepared a basic list of those materials I find essential for use both in the studio and out of doors. As my need, moods, and directions change, so do the supplies I require. There is absolutely no need for you to purchase identical equipment, but these pages may familiarize you with some of your choices.

Paints

I use tube watercolors and prefer the large Number 5 tubes. Only two companies can supply this size—Winsor & Newton, Ltd., and Renaissance Pigment Company. So, I use these brands exclusively.

A healthy watercolor requires generous amounts of moist color. There is no economy in wearing out a $13.00 brush to pick up a penny's worth of dried-out color. Be prepared to use paint liberally.

I continually experiment with new and sometimes exotic colors, but a basic palette includes only a warm and cool of each of the primary colors (red, yellow, and blue) plus a few earth colors, and black. Here is the palette I recommend for beginners:

Lemon Yellow

Cadmium Yellow Medium

Vermilion

Alizarin Crimson

Phthalocyanine Blue

Ultramarine Blue

Yellow Ochre

Burnt Sienna

Black

My current full palette consists of the following colors:

Winsor Yellow

New Gamboge

Orange

Bright Red

Winsor Red

Alizarin Crimson

Cobalt Violet

Cobalt Blue

Winsor Blue

Ultramarine Blue

Manganese Blue

Winsor Green

Black

Raw Sienna

Burnt Sienna

Burnt Umber

Opaque Colors. I'm not a purist about transparency in watercolor pigments. If I can get interesting effects with opaque white or other opaque colors, I use them. Most of my paintings, however, are completely transparent.

Brushes

A few good brushes are necessary. I have three brushes that are my "old standbys":

1″ flat, either sable or sabeline.

Number 12 round, preferably sable.

Number 6 or 8 round, a smaller pointed sable.

Most of my paintings have been completed with these few brushes. But, in addition, I have a range of other usable painting tools:

2″ and 3″ flat brushes, great for starting paintings with a minimum number of strokes.

Oriental bamboo brushes, Numbers 2 and 3, provide a flowing thick or thin line. These may fall apart quickly, but are inexpensive.

Miscellaneous brushes. I keep an old toothbrush for spattering. I use a small bristle brush

for scrubbing out lights. Any brush, if it works, is the right tool for the job.

Palettes

There are any number of commercial palettes on the market that do a good job. Actually, anything from an old white dinner plate to an enameled butcher's tray will work. I use a white plastic palette that is about 14″ x 18″ and has large color wells along one side and across the end. The wells are slightly recessed and tilted to keep color from flowing into the large divided mixing area in the center of the palette. I enjoy this large palette both for use in my studio and for painting on location. Luckily, it just fits into my French box easel that I use for painting away from home.

Pick a palette that fits your needs. Select one that is white, non-staining, and has good-sized mixing areas; the color wells should be wide enough to easily accept your largest brushes and allow for ample pigment.

Watercolor Papers

I use the French handmade paper "d'Arches" for most of my work. There are many good brands available with different surfaces in different weights (and a great range of price). Be willing to experiment with different papers—until you try several you won't have any basis for knowing what to choose to suit your own needs.

Weight. Most watercolor papers come in several weights. The heaviest papers have obvious advantages—they often don't require stretching and can be used on both sides. If the first side is a failure, you get a sec-

ond try. They also hold more moisture and allow for a longer control period in the wet-into-wet techniques. The big disadvantage of the heavy papers is, of course, their cost.

I use the 300 pound weight for most of my full-sheet paintings (22″ x 30″). I often use the lighter 140 pound stock for smaller work. This thinner paper needs to be stretched if I want the sheet to stay flat during the painting process.

Texture. There is a great range of available surfaces in watercolor papers. I use both a rough and a smooth. Each reacts differently. The rougher papers are generally better for controlled wet-into-wet applications. With the smoother papers and a drier technique the artist can achieve more brilliant whites and colors, plus brush-stroke and texture qualities that would be diffused and lost on rougher surfaces.

For a certain type of small watercolor—where I want to develop intricate surfaces and paint qualities—I enjoy using a firm smooth sheet. The two- or three-ply bristol board (kid or plate finish) is a pleasing surface that is tough enough to allow for lifting off non-staining colors to regain nearly pure whites. Smooth washes become almost impossible to control on this paper, but the range of creative textures is unlimited.

Mounting Boards

I've settled on two sizes of plywood boards that suit my needs. Both 20″ x 26″ (for half-sheet or smaller) and 23″ x 31″ (for the full sheets) are commercially available in ⅜″ thick basswood plywood. This board is thin and light and has amazing strength against bending.

It's also soft enough to accept thumbtacks, pushpins, and staples. The normal plywoods are much less expensive, but will bend under the stress of stretching paper and will break thumbtacks and pushpins. The thicker commercial drawing boards (¾" to 1") work well, but have the disadvantage of being bulkier and heavier. Masonite sheets can be used if stretching isn't necessary. Gummed tape won't stick well to Masonite and tacking is impossible. If you work unstretched—with the paper held to the board with large bulldog clips—then the Masonite board is handy.

Paper Stretching

In order to make lightweight papers stay flat during the painting process, it's necessary to stretch them ahead of time. This is done by soaking the watercolor paper for a few minutes (so it will get wetter than it will eventually be during painting), and then placing the wet sheet on a sturdy drawing board and fastening it down all along its edges. The paper will shrink, becoming taut like a drum head as it dries, and will remain flat while the painting is being done. The paper can be fastened to the board by either stapling it along the edge (staple every 2" about ½" in from the border) or by taping it down with strong 1½" or 2" wide gummed tape. Masking tape won't work. You need the gummed tape that has to be moistened and then pressed down tightly to hold against the power of the shrinking paper. The tape should be positioned all the way around the watercolor sheet (four precut pieces of tape) and should lap over about half on the paper and

half on the board. Store the boards of freshly stretched paper flat until the pages dry. If you do more than one sheet at a time, you can stretch on both sides of your boards and then stack them between sheets of old newspapers until you're ready to use them.

To remove the paintings when you've finished, cut the tape down the middle; or, if you have used the staple method, cut the painting free just inside the rows of staples and then pull the remaining strips off the board to clear it for future use.

Easels

Once again, each artist usually ends up with his own preference when it comes to some method for holding a board during painting. In my studio, I have a large drawing table that can be tilted to any desired angle while I work. A sloping surface can be achieved without a special table by propping up your board with a wooden block, box of tissues, or any other handy object. Many painters work outside on the ground without an easel. They lean their work board on their painting pack or kit to achieve the desired angle and either sit on the ground or use a small stool. I prefer to stand while I work and have found my French box easel (with adjustable legs and tilting rack) to be completely satisfactory. Most of the lightweight, aluminum, photography type easels I've found to be too flimsy to hold a big board as steady as necessary.

The cheapest easel, and one of the handiest, is a cardboard carton that has had its top cut to a desired angle to support a drawing board. Supplies can be carried in the box as well. In

the studio, a box with a very low-profile wedge will work well on any normal table. For working out of doors (either sitting or standing) it's possible to adjust box heights so your board is at a comfortable height and angle.

Miscellaneous Materials

Throughout the various chapters of this book I plan to introduce some unique painting tools. I won't list them all here. They range from blotters to matboard scraps to paint rollers. The use of the out-of-the-ordinary tools is described in the text wherever it is introduced. My basic philosophy is that *anything goes*. If you feel like trying something different, by all means experiment. If it works, fine! If not, you've still enlarged your knowledge of the painting craft.

Summer Textures (Overleaf). D'Arches paper, 13½" x 20". Here I used calligraphy, spatters, and a variety of stampings to stress texture.

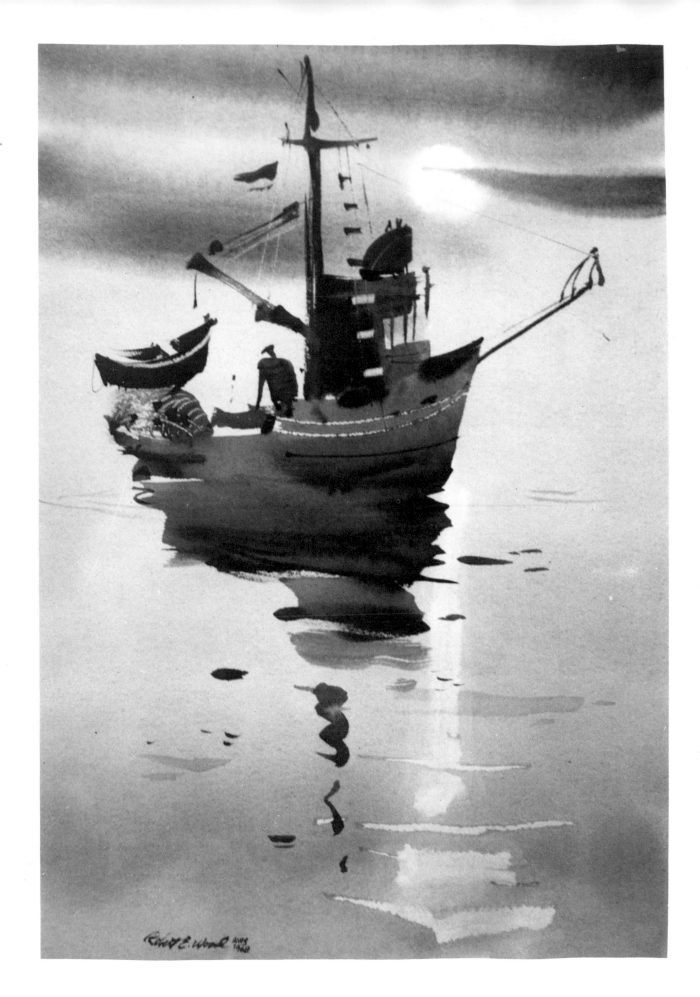

3.

The Glaze and Silhouette

Morning Moon. *D'Arches paper, 13½" x 20". Here the glaze was used to establish a color mood and to slightly develop some identity in the background. The moon was lifted out with a clean brush while the glaze was wet, and the soft clouds were struck in immediately afterwards. The reflections in the water were made with squeegee strokes using the flat handle of my brush. After the underglaze was dry, I laid in a linked silhouette that needed very little interior development to make a finished statement.*

In all of my painting and drawing experience, from the time of my earliest art training, I was taught to see things by drawing lines around them. In truth no such line is found in nature. Objects exist side by side or one in front of another, not because of a little, thin wire of an edge, but because they are mass against mass, value against value, color against color Our eye reads these contrasts and we interpret them as solid objects. By staging what I call the character silhouette over a glowing glaze of color, we can reduce the complexities of nature to an effective watercolor statement. It's a graphic way to interpret the structure of nature in a watercolor by capturing its character in bold, simple shapes.

In this chapter our first concern will be the initial layers of color washes on the page—the glaze. The idea is to lay several layers of glowing color on the page and let it dry, establishing a glaze as an underpainting. Then you paint the subject over the glaze in darker colors, forming a silhouette of linked shapes.

Beginning in this chapter is a variety of suggested technical exercises and painting problems for you to try. It's not really necessary to work each exercise in sequence, but I do recommend that you read them through. There is a definite building of one lesson on another, using facts explained in previous chapters in later ones. In this chapter, which lays the foundation for the book, there will be two technical exercises and a painting problem.

Indirect Glaze

There are two basic ways to paint a watercolor glaze. The traditional English technique, the indirect glaze, is the slower and more patient method. In the indirect method, you start by painting a light layer of color over the entire page. Let it dry thoroughly, and then superimpose still another layer. The eventual color of the glaze is produced from the combined number of layers. Each layer has its separate color and value. If previous washes are thoroughly dry the colors can be laid down layer upon layer without disturbing the paint underneath. The final effect is one of a glowing, fresh page. The pigments have not been ground together into a common muddy gray. If we examine them under a magnifying glass, the colors are sitting there side by side, almost impressionistic

14294　SANTANA HIGH SCHOOL LIBRARY

in character. The eye mixes in the color and there is a glow in the finished painting that almost seems to emit light.

Granular Wash

It's possible to emphasize the color variation in a glaze by overpainting with a layer or two of a granular wash. Some pigments are more opaque than others. Yellow ochre, raw sienna, cobalt blue, and manganese blue are examples of opaque colors. When painted directly on white paper they glow with the rich brilliance of most other colors, but when flowed on top of darker colors they settle into the hollows of the paper's textured surface and create an obvious sedimented wash. This granular effect can help enhance the glow of the glaze when applied over contrasting colors.

Staining Colors

Whereas the more opaque colors tend to sit on the surface of the paper and create a granulated effect, there are other pigments that are highly transparent and are practically liquid stains. Staining colors will penetrate the paper and any color under them. They can be used in building a glaze, but you should be aware that they'll have the effect of dyeing all the colors they cover, and hence can destroy the effectiveness of a granular wash. If you want the more opaque colors to retain their identity then just flow them on last. Strong staining colors should also be avoided if you expect to lift out whites from the glaze later. It's hard to remove such colors as phthalocyanine blue and green or alizarin crimson. These colors are highly transparent and are next to impossible to wash out after they have set, but they do have advantages. They're ideally suited for overpainting other colors without losing luminosity. Once again, there is no strict formula that must be followed when building a glaze, but it does pay to know the different effects the more staining colors have when laid over and under one another.

Direct Glaze

The method we will be using to paint our glazes is a timesaving one, the direct glaze, that allows us to paint an effective glaze in one painting period.

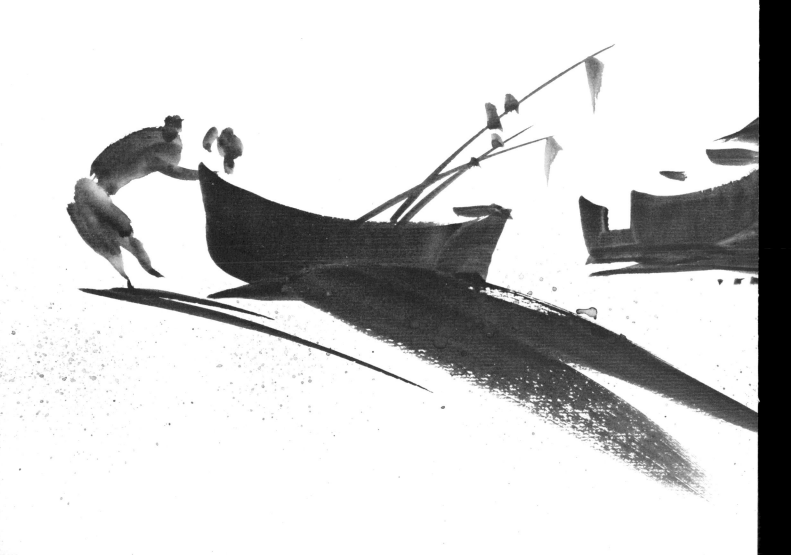

Dory Fleet. Drawing paper, 18" x 24". Think shapes, not outlines, and practice linking individual parts of the subjects into bold, dramatic silhouettes. Here the boat blends into its cast shadow and then unites with another boat or figure or building. It creates a structural symbol that is more interesting than displaying all the parts separately.

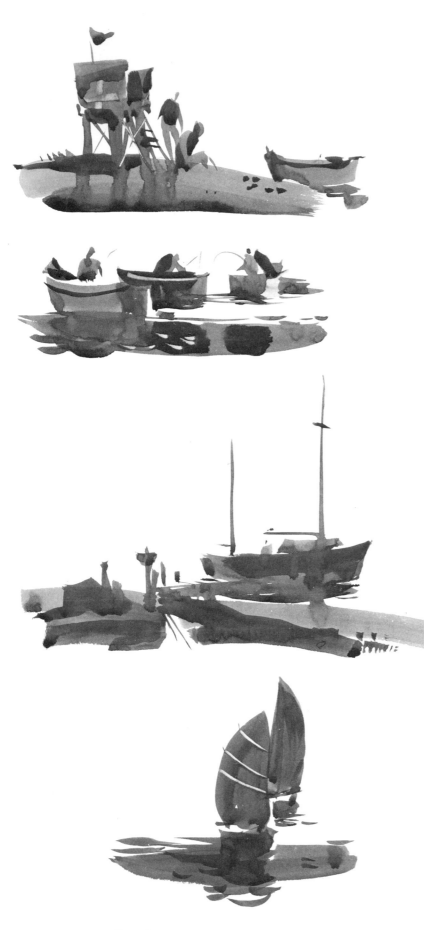

Spot Silhouettes. *Drawing paper, 18" x 24".*

We won't wait for the first color to dry, but will lay one color down and immediately paint another layer on top, with a third layer over that. By keeping the page totally moist, brushing the whole surface with each application of a new color, we keep the paint active and alive. It will not mix itself into mud if a light, fresh touch is used (just the tip of a large soft brush) and ample color is carried onto the damp page. This method, too, will superimpose layer over layer, letting the color sparkle with individual microscopic spots of pigment.

Warm and Cool Contrasts

If I want a predominantly warm glaze, then I'll paint a first layer or two of light-valued cool colors. I then immediately overpower these tints with layers of stronger color that still fit my major warm theme. If I want a basically cool painting plan, the reverse also applies. A delicate warmth underneath the bolder cool glaze provides relief and contrast and also adds to the final glow of the page. The real key to creating an effective glow, besides laying color over color without disturbing the paint underneath, is the controlled use of the combinations of both contrasting warm and cool colors.

One other point should be mentioned here. Complimentary colors neutralize one another. If you construct a glaze of equally bold values of warm and cool washes, the final result will be a fairly subdued page. If it's a smoggy day quality you're after, this may be your choice. If your goal is a more colorful effect, then let one color dominate. In planning a bluish sky, adding a hint of

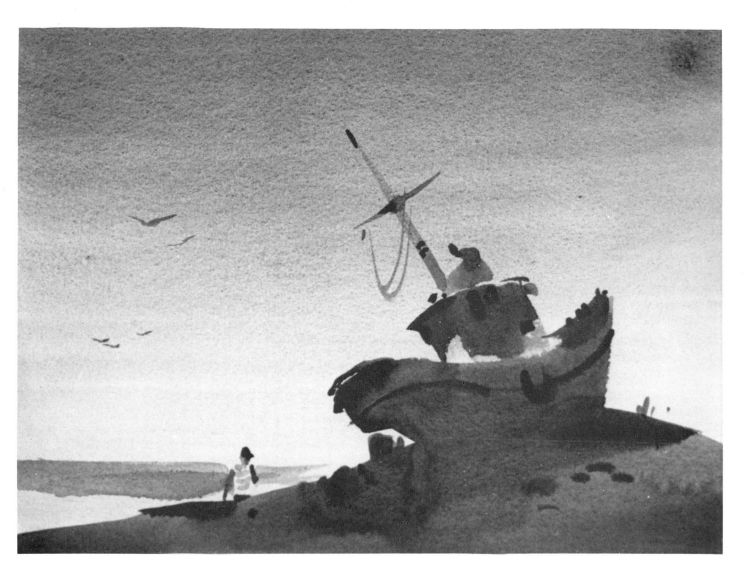

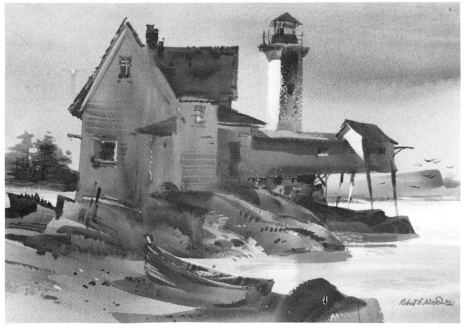

Beached Boat (Above). D'Arches paper, 9" x 12".

New England Light (Left). D'Arches paper, 13½" x 20". This finished painting is a good example of the unified silhouette that can be constructed by using a backlighting plan. The bold wash that established the overall silhouette was originally one color and one value. The development of the divisions within the silhouette can therefore be amazingly fresh and casual.

warmth (delicate values) under the basically cool sky (stronger middle values) will provide a most luminous glaze. Conversely, use just a bare tint of cool under a bolder combination of warm layers for a glowing, sunny mood. Sunlight is composed of a full spectrum of warm and cool colors. A painting planned with intelligent intermixings of warm and cool colors for most of the surface will have a natural look without the harshness of too much raw color. Nothing disturbs me quite as much as the "amateur blue sky;" the sky that is totally cool and artificial because of its single-color richness. It's generally wise to save pure, rich colors for the smaller final accents in your painting and for man-made objects that they can characterize correctly.

Color Unity

Glazing has the advantage of giving color unity to the final work. In nature, we see a unity caused by reflections of color from one area to another. For example, the warm ochre of desert sand is reflected in the sky above it. The burnt sienna of red hills might be echoed in adjacent sand. The warmth of the city bounces up into the smogginess of the air near the earth. When used as an underpainting, the glaze unifies the total color of a finished work by gently imposing its character through all the bolder transparent darks that develop the subject in the later stages of overpainting.

Building the Glaze

There are no strict formulas for the selection of colors that will create effective glazes. Different combinations of colors develop different color moods. It's as simple as that. I do believe in experimenting with new combinations of colors in order to break free from the limitations of established patterns. However, I have some definite guideposts in mind whenever I start a new glaze for an underpainting. First, I want to make sure that the glaze remains fresh and sparkling. I plan to work quickly and use the biggest brush that will do the job comfortably. I don't want to overwork the painting, especially at this early stage—the fewer strokes the better. I'll also consider value control and contrasts of warm and cool. To keep the paint luminous, I try to do little neutralization or mixing of colors on my palette, but instead carry pure color to the page for each successive layer. If the color is dulled on the palette and then muted again on the page (by combining it with previous colors), the final product can turn to mud.

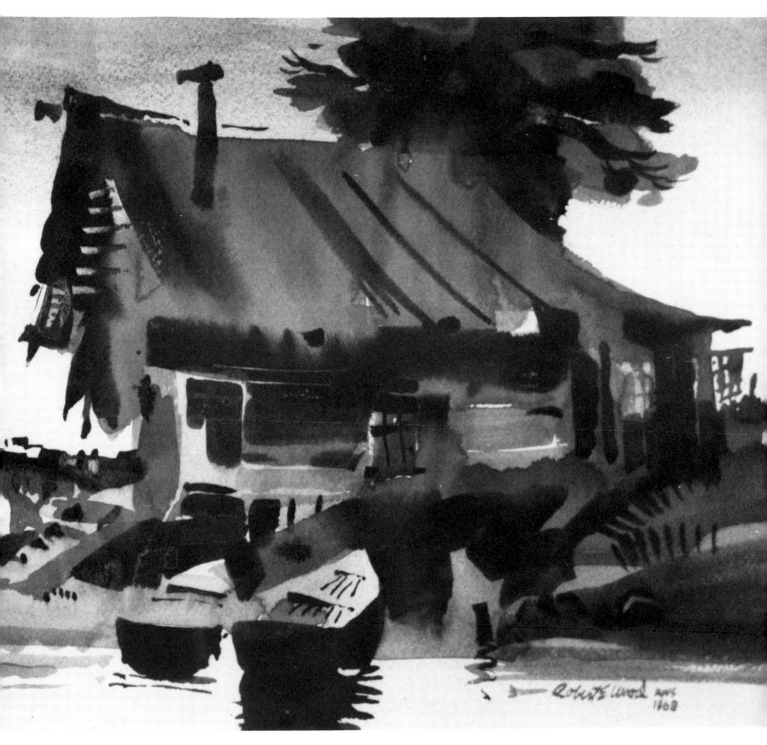

Cabin on the Shore. *D'Arches paper, 13½" x 20". This is an example of a glaze and silhouette two-phase painting. Disruptive openings (sky holes) are kept to a minimum. The edge of the silhouette tells the story and allows the interior divisions to work well in a lost-and-found manner.*

Wyoming Farm. *Drawing paper, 18" x 24". Big-brush shapes establish a linked pattern that distributes an interesting design throughout the page. On top of this simple foundation, I used some bold calligraphy to symbolically describe the variety of surfaces and textures. Notice the concern for scale in both the original silhouettes and the detail development.*

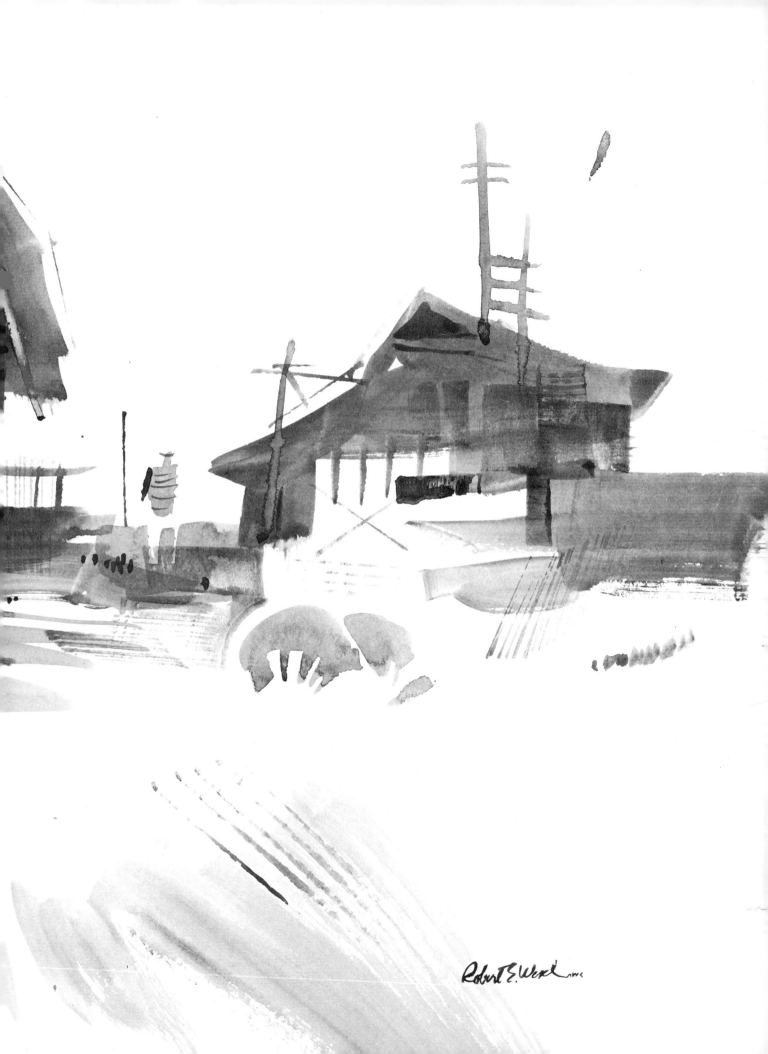

Exercise: The Glaze

For this exercise you'll need a half-sheet of good watercolor paper. It should be stretched. You will also need a 1" or Number 12 brush and the following colors: a light yellow, cobalt blue, and manganese or cerulean blue. A second glaze exercise will use yellow ochre, burnt sienna, and black. If you don't have these exact colors it isn't too important. Use approximate substitutes. Mark off two separate 9" x 12" painting areas on the paper and set your board up at a slight angle (15° slant, or about 3" to 5" of lift at the top end). Get comfortable. Have generous amounts of your selected colors available on your palette.

Each layer of color will be applied as a graded wash, darker at first and then lightening as it progresses up or down the page.

When you're ready to begin the exercise, dampen your worksheet with a brush or sponge and mix a good-sized puddle of your first color in a medium-light value. It will be important to work quickly and efficiently. Paint smooth, horizontal strokes across the page, letting each succeeding stroke slightly overlap the preceding one so the wash will be smooth. The color in the brush will naturally get weakened, and the wash will get lighter as it's carried along the page. This gradation, however, is what you want to achieve. Don't worry about making the washes stay precisely within the picture area. Make it easy on yourself and stroke the paint freely through the side guidelines and continue it right off the end of the paper. It's always possible to mat a painting back to the

original dimensions and thereby clean things up again.

Read the instructions for the exercise before you begin the first wash of the glaze. It's important to know where you're headed before you start. The freshness and vitality of a good watercolor is achieved through a directness of handling that comes from knowing what you want to accomplish, then proceeding freely with a sure touch.

When you have finished the first glaze, try another using calm, earthy colors. First lay on a graded wash of yellow ochre, then one of burnt sienna, and add contrast with black.

Step 1. *With a well-mixed puddle of yellow paint,* middle-light value, *proceed to lay a graded wash from the bottom of the page. Use long, smooth horizontal strokes, working progressively up the full page. You may have to replenish color in the brush for the first few strokes, but then there should be ample color to blend to a lighter value at the top. You can immediately reinforce this first layer with stronger color if necessary. This first wash should blend smoothly from a middle-light value at the base to a light tint at the top of the page. Clean your palette and brush, and move directly to Step 2.*

Step 2. *Work quickly so the original wash does not dry. Prepare a middle value of pure cobalt blue. This time, from the top down, paint another graded wash directly over the first. This wash should blend from a middle value to a light as it reaches the bottom of the page. Work with a light touch of the brush.*

Step 3. *The third wash will be manganese blue, starting at middle value, blending from the top of the page to a light value at the bottom. To finish, wash and squeeze out liquid from your brush, then mop up any excess color outside the picture framework. Leave your board at an angle and let the page dry. You have laid a basic glaze.*

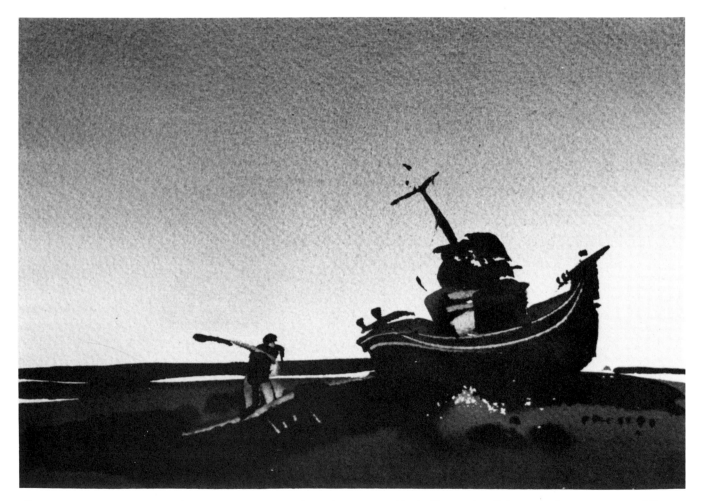

Step 4. *After the glaze has dried it may appear to have lost some of its brilliance. It will be turned on again by adding a dark contrasting area at the base of the page. Using some of the same colors that were used to build the glaze (in this case primarily cobalt blue) paint a rich, dark transparent band about 2" wide across the base of the glazed sheet. If you want to give it a bit of form—such as a simple silhouette of trees, a boat, or shoreline—fine, but your objective is simply to add a dark foreground that will display the glow of the glaze.*

Exercise: The Silhouette

The previous exercise has allowed you to practice the development of a glowing glaze that can be used as an underpainting for a subject of your choice. You've already discovered that the glaze has qualities of freshness, sparkle, and luminosity. You've also learned that the desired glow does not really come to life until there is a bold, dark mass developed to show it off. The problem now is to construct some simple silhouettes of different subjects that have interesting design and character and can therefore be used successfully in combination with the glaze for a final painting.

Initially, the easiest way to simplify your subject for this exercise is to imagine it as being backlighted. This way the various parts of the subject matter will become linked into a unified silhouette pattern. Choose the subject for the silhouette from those you know. Some linking of form is necessary to create a unified design, regardless of the subject matter. Use shapes that have some size variation, and distribute the patterned interest throughout the page. I recommend a close-up view of your subject rather than a distant one that would provide only tiny details and a lot of leftover negative space. The interior of the silhouette should not be cluttered by detail or cut by too many sky holes. To create the character of the silhouette, differentiations should be made in shape with careful attention toward establishing a descriptive edge or contour. When practicing these first character silhouettes, try not to depend on outline or detail within the subject.

Step 1. *Mark out four 7" x 10" painting areas, and use one of these spaces for the first phase of this simplified silhouette. Use any transparent dark color. The first concern will be distributing some scaled shapes about the page. Treat the subject as a close-up composition so it can display a variety of shapes. Try to distribute and balance the major masses in the composition. Work without pencil guidelines so you can freely adjust these first estimations of subject placement.*

Concentrate on the information that can be expressed by the profile; paint shapes, not outlines. Later, when you get into the real painting process, a little local color variation and a minor amount of detail or calligraphy will aid in finally describing and separating objects within the massive silhouette.

For this exercise you'll need some inexpensive drawing paper, approximately 18" x 24". Work with a large brush (1" flat or a Number 12 round) and a bold, transparent dark color. I'll be using a combination of Windsor blue and burnt sienna. Merely copying my ready-made silhouettes will teach you little. To truly benefit from this exercise you must make translations of your own. Use your sketches or previous paintings as a source. Practice painting subject matter that you're familiar with, a subject you know well enough to add authentic details and interest to the character of the silhouette. On such inexpensive, large paper you should feel free to experiment. It's well worth the time invested.

Step 2. Now proceed to develop the profile of the various parts of the subject. Stay away from finishing details, and try not to depend on line. Be especially careful of using too many lights that may have a tendency to sneak out from between brushstrokes. Keep the shapes bold, simple, and informative. If the basic silhouette isn't interesting and effective at this stage, all the detail in the world won't help.

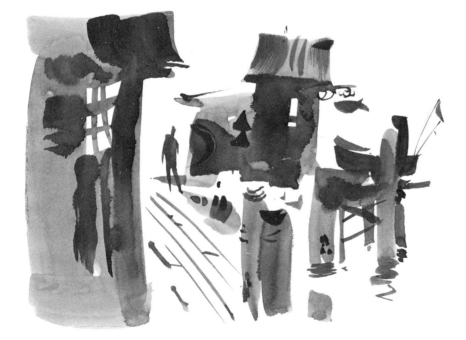

Step 3. It is now time to add a minimum of bold detail. Take time to work some additional character into the edge of the silhouette. You can also develop a few divisions within the mass of the silhouette with further darks and slight color changes. These variations within the larger mass can be amazingly casual; let them be fresh and unworried, a bit hit and miss.

Painting Problem:
The Glaze and Silhouette

You've practiced the glaze and can put down a fresh, glowing page of layered color that creates a desired mood. You've also experimented with large brush silhouettes. Now you're ready to do a two-phase painting with both ingredients, the glaze and the silhouette.

The only difference between this painting problem and the exercises is that you'll use a good watercolor paper and paint the bold silhouette directly on the dried glaze.

Use a stretched half-sheet of paper. Paint the glaze in your own choice of colors, contrasting combinations of warm below cool, or cool below warm. The step-by-step illustrations will again explain the problem and will list the particular colors I used in this painting. You'll note that some of the graded washes are controlled a little differently than in the glaze exercise. Read all three steps before beginning so you have the new plan clearly in mind.

Step 1. Dampen your page with a sponge or brush and prepare to lay your direct glaze in graded washes in the usual manner. Use your 1" brush. The first wash is yellow ochre, middle-light value at the base and thinning toward the top. The second color is raw sienna, middle-light value at the top and thinning to a bare tint at the base. Work the whole page with each successive layer to keep the paint damp and active. Next use a manganese blue. This graded wash will start as a middle value, and it will work from the top down and from the bottom up. Let the washes gradate quickly so that you keep a light glow horizontially across the page slightly below center. The last wash is burnt umber. Start at the top with a middle value and fade this color almost completely in the upper two-thirds of the page. Let your finished glaze dry.

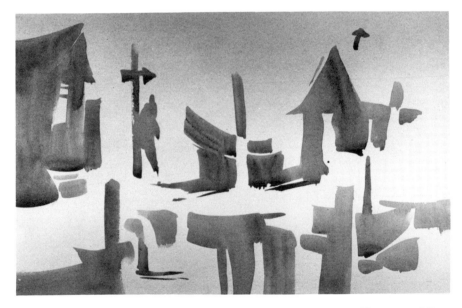

Step 2. Now get ready to start the foundation patterns for your silhouettes. Mix a large puddle of burnt umber in a strong middle-dark value. Make up your mind as to the basic structure of your composition, and then work quickly to brush in approximate shapes for the whole layout. Flow the color generously into the shapes so they will remain wet for as long as possible. Keeping your board at just the slight 15° angle will help slow the drying.

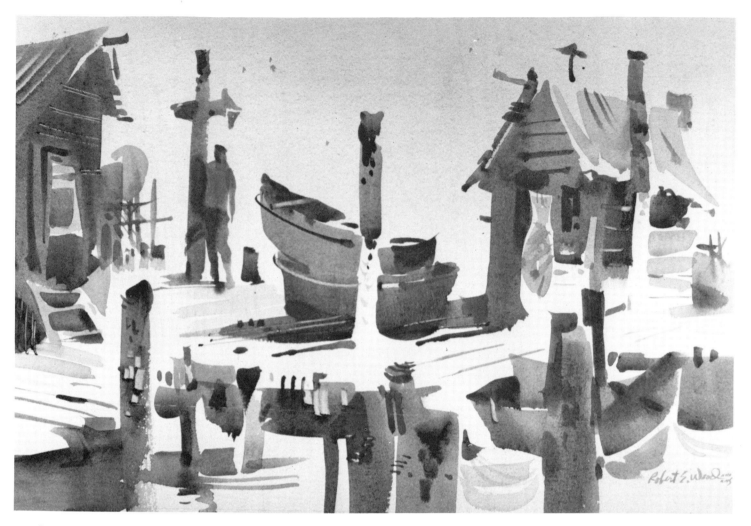

Step 3. *Still working with your big brush, but now using a variety of colors (burnt umber, burnt sienna, blues, and reds) strike some local color into the still damp first stages of the silhouette to establish some different values for the various sections of your subject. This color can be mingled loosely into the damp pre-painted shapes. Balance the whole composition with darks and richer warm and cool colors. When this stage is finished, allow the page to dry. One of your pointed brushes can now finish the painting. With clean rich color, and with some colorful transparent darks, distribute brush pattern accents of symbolic detail. Don't start wrapping lines around things. You are still practicing a shape and silhouette plan, and this is the time to think more and paint less.*

Gray Wharf *(Overleaf). D'Arches paper, 22" x 30".*

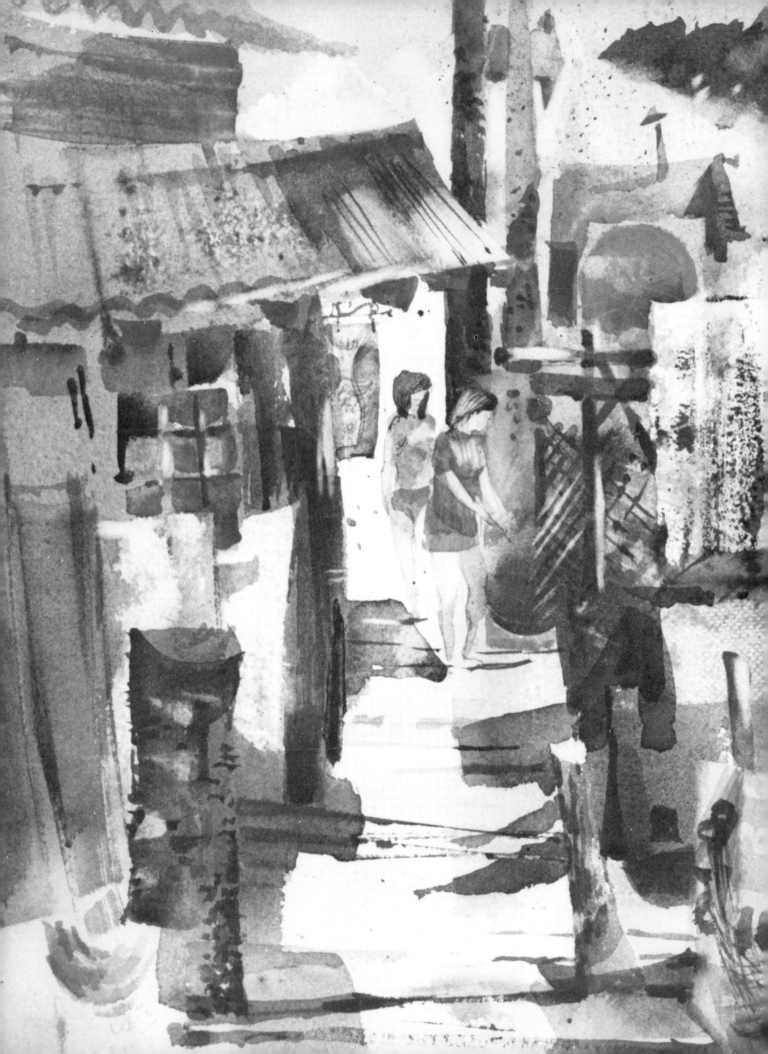

Sunshine East. *D'Arches paper, 22" x 30". My structural plan for this painting was a variation on a rectangular theme–a division of the page into an interestingly scaled and balanced composition. After the underpainting was established, I let the audience select which side they wanted "up," and then I developed the structure of the subject. The bulk of information in the painting is in the rectangular shapes that carry the blocky suggestion of buildings. A sprinkling of diagonals and curvilinear rhythms add contrasting accents to the basically static composition.*

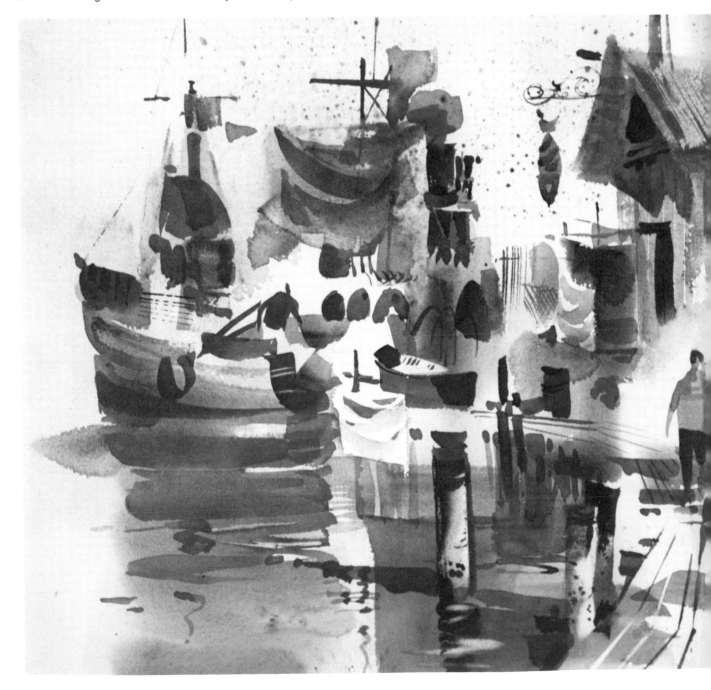

4.

Design Unity

In this chapter I have no intention of forcing you into any grand change of painting style. I believe that excellent painting can be done both realistically or in a completely nonobjective vein. It isn't the degree of realism or abstraction that makes a painting good or bad; there can be good or bad results within any style. But much of the conservative painting I see suffers heavily from lack of underlying design control. Nothing seems to separate the pro from the amateur more sharply than this area of abstract organization.

Subject Matter

Most students have a good sense of design until they try to portray specific subjects. Then the basic problem of drawing the subject becomes such an overwhelming concern that organizing the total composition is overlooked. A good painting is not just a group of well-painted parts. There are many skillfully painted scenes—the sky perhaps a beautifully diffused wet-into-wet rendering of clouds, the second area a ridge of triangular-shaped trees, a third area filled with blocklike shapes, such as a house and barn, and the foreg-

round arabesqueing, flickering strokes of water or waving grass. Each area is convincing in character, yet the painting is divided into bands of such drastically different rhythms that it lacks any unity.

It's rare for nature to provide a ready-made composition with a completely satisfactory design. A good painting is usually a reorganization of the subject rather than a mirroring of nature's real arrangements. Granted, nature offers a valuable and unlimited supply of exciting information and new ideas for paintings, but it's up to the artist to take these separate ingredients and orchestrate them into harmonious compositions.

This chapter will present the basic elements of design needed for organizing your paintings, and several exercises and painting problems planned to better acquaint you with handling these abstract considerations. Accurately rendering subject matter will not be a primary concern, although the best conservative painting is built on the same abstract principles we will be exploring. Feel free to experiment with these valid, nonobjective goals for their own sake.

SANTANA HIGH SCHOOL LIBRARY

Static. *A firm, solid, architectural feeling is expressed by the meeting of vertical and horizontal lines or shapes.*

Slow Dynamic. *These curvilinear shapes set up an undulating rhythm that displays a calm type of movement.*

Fast Dynamic. *A rapid tempo is expressed by these diagonal forms meeting at sharply pointed, acute angles.*

Design Elements

There are three basic elements of design: *static, dynamic,* and *magnetic.* The following exercises will deal with the concepts of the first two. The third element, magnetic, refers to the power of rich color to demand attention over subdued, grayed hues and will be explored in later chapters.

Take a look at the sketches shown nearby. The first sketch displays the character of the static elements—firm, stable, non-moving structures. Different tempos of dynamic elements are shown in the next two sketches. A slow, curving theme dominates the first; a faster, sharper rhythm characterizes the second. At this point let it be enough to identify and be aware of different responses to these various design elements. How to put them to use will be the concern of the exercises and painting problems that follow.

Major Design Goals

I believe that painting should be at least partly intuitive, or more accurately, should evolve through the apparently uninhibited action that is the result of a well-practiced method of working. A painter might work a lifetime without verbalizing his reasons for working in the way he has developed, but for the purpose of teaching it's necessary to set some logical goals for a period of study. Therefore, I'll list some considerations —concepts of design, *not* rules—that I feel can be useful aids in this process of learning to become a more competent picture builder.

Unity. A painting benefits in its overall organization from a single, predominant design theme. The choice of a major theme (either static or dynamic) might be suggested by the subject matter, or it could be the arbitrary decision of the artist. Almost any subject could be handsomely organized on a dominantly static structure (rectangular in theme). The same subject could also be painted with a slow, curvilinear dominance. Neither is automatically better than the other, and each controlling theme will evoke a different feeling. The main search is for a device (design unity) that can organize the shapes within your painting and prevent them from being a chaotic gathering of unrelated bits and pieces.

Scale. By controlling the variation in the size of shapes, you can create dramatic tensions in your compositions. It isn't enough to paint "things" well; you should establish a scale of large, middle-sized, and small shapes that have a relationship to each other. Unless the artist consciously develops scale, the pieces of a painting have a tendency to become all middle-sized and therefore visually dull.

Balance. The most formal design is a composition with symmetrical balance—one in which each form on one side of the page is balanced by a similar shape on the other side. The artist, however, often creates an asymmetrical balance to produce more tension and variety. Much like a father and child on a teeter-totter, a small shape in the spaciousness of one side of a composition can balance a larger object nearer the center of the page on the

other side. Such contrasts provide bolder statements of scale. Consider also the balance of weight, space, warm and cool colors, softness and crispness, and texture as well as the size of shapes. Balance is an all-inclusive concept.

Containment. I believe an artist's duty is to make a painting so complete that when it's framed and put on the wall it seems to say, "I'm all there is. There is no more." I try to avoid creating a snapshot quality—as though the piece of nature I'm painting runs off the edges of the page without any change in intensity and is obviously just a part of something greater. One certain way to make a design complete in itself is to turn it into a vignette, a pattern that dissipates entirely before it reaches the borders of the page. The vignette provides perfect containment, but it can easily become an unimaginative and dangerous compositional crutch. Shapes can fill the picture area and even run off the page without destroying containment if care is taken to subdue them as they reach the edges. Bolder accents of dark and light color and complexity will force attention into the painting and further the desired sense of completeness.

Combining Elements

In the exercises that follow you'll isolate the various elements of design, working with just one theme at a time. When you actually construct a painting you'll find yourself confronted with the problem of integrating all the design elements at once. Again, there are no strict rules to follow, but I'll offer some ideas about the abstract organization of paintings.

The all-rectangular study can become dull and uninteresting. Add just a few rhythmical curving patterns and the static shapes will appear more firm and stable. In the same way the completely warm painting is not nearly as hot as one that contains a minor amount of cool. Unity and variety are contrasting terms. It's not too hard to see the advantages of each when we consider them separately.

Certainly a painting is more effective if it has a unified design structure. Conversely, arrangements of shapes are more visually tempting if there is some contrast or variety within them. This can be done by making a bolder statement of scale or changing a shape, inserting texture or new color. The problem, therefore, seems to be, "How do we keep the overall organization unified and still strive for interest through the addition of variation?" One way to solve the problem is to have a single dominant theme with the relief of a minor amount of contrast (see the nearby illustrations). The static composition that is supplemented by a little spice of curvilinear or diagonal elements of design is one possible answer. A boldly active, dynamic design benefits from a touch of horizontal and vertical (static) stabilization. An indecisive statement is the result if proportions of static and dynamic elements are about equal. The glaze exercises in the preceding chapter applied a similar theory about color. The cool painting with a slight relief of warmth—or the reverse—makes a more decisive statement than one that is half warm and half cool.

Static Dominance. *Rectangles with a little relief of the dynamic, both curves and diagonals.*

Curvilinear Dominance. *The major theme of slow, rounded shapes is given stability and variety through the addition of some static and diagonal shapes.*

Diagonal Dominance. *This dramatic, sharply active design is supplemented by firm horizontal and vertical inserts. A few delicately curving shapes add further variety without competing with the major unifying theme.*

Exercises: Static, Curvilinear, and Diagonal

For these exercises you'll need some inexpensive white drawing paper. My illustrations are on an 18″ x 24″ sheet that has been marked off into eight separate rectangles, each 4½″ x 7″. Use any dark color for these experiments in three values—light, middle, and dark. You'll need your 1″ flat and Number 12 round brushes.

The three separate exercises (static, curvilinear, and diagonal) will let you explore and improve your design ability without injecting the confusion of subject matter. On the first sheet, work with a static theme and make an arrangement of many overlapping rectangles. Establish an organization of shapes that has, first of all, unity, but a unity enhanced by variety resulting from a good sense of scale. A checkerboard of equal-sized pieces can be very dull. It's up to you to control the dramatic change in size of your shapes from large to middle-sized to small. Balance and containment will be the additional concerns in these trial and error experiments.

I recommend working directly with the brush, painting and adjusting your rectangles as you go along. Drawing penciled outlines of your shapes ahead of time is not only a waste of time, it can lead to a method of working that leaves no room for spontaneity. You should really get the feeling that you're juggling patterns as you build the design. It's a growing process—pieces are inserted, then counterbal-anced. Don't expect the finished composition to be fully determined before you start. If you've been a painter who has concentrated solely on describing subject matter, you might find this focus on nonobjective design relationships as confusing as a foreign language. Take this chance to become acquainted with these additional —and vitally necessary—design components of unity, scale, balance, and containment.

Static Variations, Step 1. *With a light value of any strong color (I happen to be using Payne's gray) distribute some overlapping rectangles on the page. Build some large shapes, some middle-sized, and a few small ones. Try to be aware of the unpainted light spaces (negative areas) so they, too, have a range of sizes and a balanced distribution. The sense of scale will be stronger if some of your shapes are large enough to touch the edge or actually run off the page. Let this first step dry.*

Step 2. *In a deeper middle value, repaint some of the light-valued rectangles to further identify the individual shapes. Notice a feeling of depth developing as the shapes appear to hang in front of one another, or peek out from behind. Make these overlaps clear and obvious. You can add new rectangles at this stage to adjust the balance and increase the sensation of scale. Let this layer dry before starting the final stage.*

Step 3. *Now complete the composition using a strong, transparent dark value. In the process of overpainting and adding new rectangles, you can make further balancing adjustments and proceed to cluster the smallest shapes into areas of finished complexity. Build some of these last strong darks directly against open whites and they will become a climactic focal point. Keep these accent darks away from white at the edge of the page to retain the feeling of containment.*

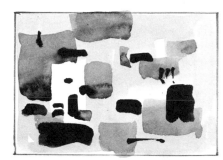

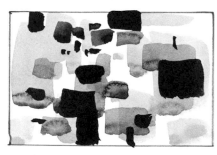

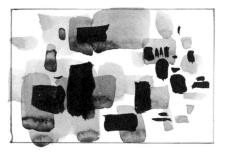

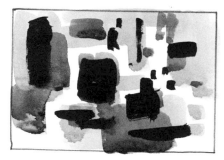

Step 4. *Now it is time to fill the remaining workspaces with similar explorations of your own design. To increase the feeling of scale, build a few really big shapes in the first light value. In each new plan, invent arrangements that distribute the masses differently. Use your instincts–the goals are unity, balance, scale, and containment. Once again, let me caution you to avoid thinking of subject matter at this point so you will feel completely free to observe, adjust, and control the major abstract goals of this design exercise.*

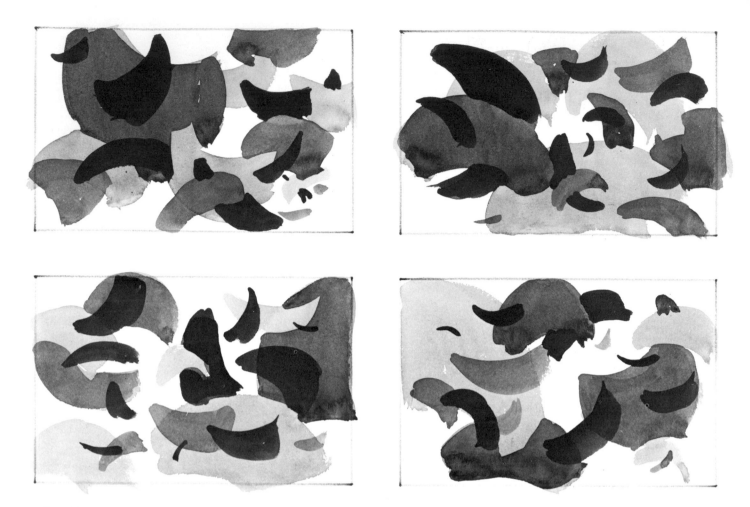

Curvilinear Variations. *These illustrations are to prompt your second exercise. The only change is in the shape you will use. This time make forms with calmly curved sides to introduce a slow-speed dynamic motion to the designs. If you become bored with your color choice, by all means try values of another color.*

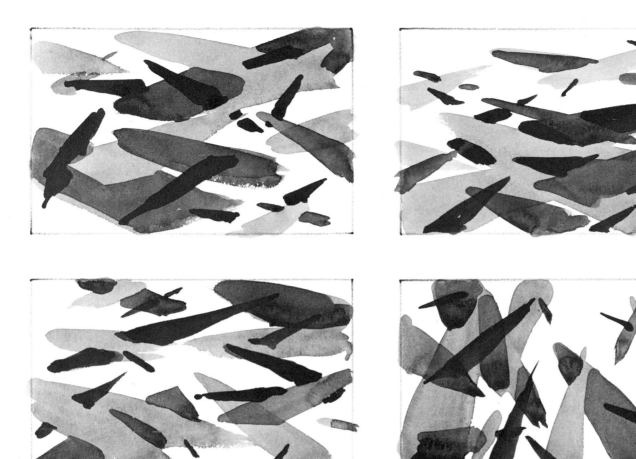

Diagonal Variations. *This third exercise involves diagonally intersecting forms in fast-paced dynamic designs. To force variety into these plans, you might try one study with an emphasis on diagonal shapes that have a horizontal rhythm. In another, stand the majority of the diagonal forms on end and emphasize the vertical. Fill some plans with great complexities. Next, have a more open and spacious plan. Be willing to experiment, explore, and invent so you can release the good design sense you have within you. Carry on!*

Painting Problems:
Introducing Subject Matter

The technical exercises helped to enlarge your awareness and control of the basic elements of design. You practiced building nonobjective compositions with a unity of design. You distributed shapes with an eye for satisfying, balanced arrangements. You were able to expand and diminish shapes until you achieved a dramatic sense of scale in your presentations, and you were able to keep the patterns from rushing off the page, thus establishing a feeling of containment. Now it's time to make continued use of these important design considerations as we add subject matter to the picture-building problem.

The three demonstrations that follow should be almost self-explanatory. Each will start with an underpainting that is arbitrary in its conception (one static, one curvilinear, and one diagonal). This underpainting will be the unified structure of design on which the subject matter will be superimposed in the second phase of the painting problem. I think that you'll have greater success if you consider these projects as design problems, not paintings. Subject will be used and be

important, but don't allow yourself to become so concerned with identifying a specific bit of material that you lose the freedom to be a good designer. Chose a subject you know well and you'll have a freer hand in adjusting it to your needs.

Before you start painting, let me make a couple of suggestions. The abstract underpainting in each demonstration should be kept simple. More shapes and activity will be added when the subject is superimposed. If your underpainting gets too complex, then the final result will be overworked and confusing. Secondly, keep your underpainting no darker than a middle value. Save the middle darks and final darks for bringing your subject into focus, and you'll have little trouble producing a clear and structural statement.

I've used 18" x 24" inexpensive drawing paper for these paintings, divided into four 7" x 10" work spaces. I think it's an advantage at this stage to feel free to experiment. You'll need two colors (burnt sienna and phthalocyanine blue) and your brushes.

Static Plan, Step 1. *The first step in this two-phase painting will have exactly the same nonobjective goals as the preceding exercises. The underpainting design will have a static unity of overlapping shapes. Just paint shapes, not things, and concentrate on scale, balance, and containment. Use colors up to, but not deeper than middle value. Develop various mixtures of burnt sienna and blue to distribute warm and cool color throughout the design. Remember to keep this phase uncomplicated—the subject is yet to come.*

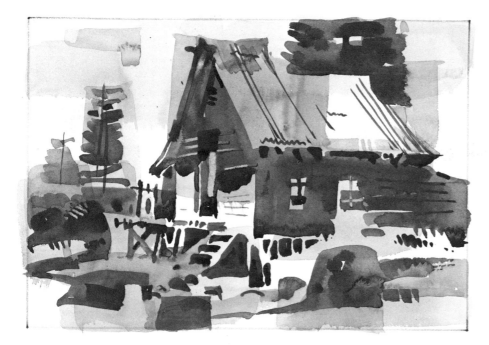

Step 2. *Now start suggesting the basic arrangement of your subject on the page. I recommend doing a close-up view so you have large, designable shapes to work with. Paint directly with a big brush using a middle-dark mixture of color. Paint the shapes that give the first, simplified suggestions of your subject, concentrating on distribution and balance. You don't have to "fit" your subject exactly to the underlying structure. Some shapes will have to be superimposed in a fashion that "jogs" the design beneath. The goal of this organization is to have unity in both the underpainting and the subject. Translate the forms of your structures into primarily straight-edged, static shapes. A few diagonal and curving rhythms will supply some interesting contrast.*

Curvilinear Plan, Step 1. *Start this plan in the same manner, but this time establish an understructure that has a slow, dynamic unity. There is no need to try and arrange this design to fit the subject that will be painted later. It's more important to make certain that the foundation of shapes has a good balance, bold scale, and a pleasing distribution of warm and cool colors.*

Step 2. *The subject will be introduced by simple shapes of middle-dark values, and should be freely influenced by the curvilinear design theme. Use horizontal, vertical, and diagonal movements, but don't let them overpower the major theme. One way to handle these straight-edged shapes in a subordinate manner is to intentionally interrupt them. Let the underpainting suggest just how and where the long straight edges can be broken into smaller segments.*

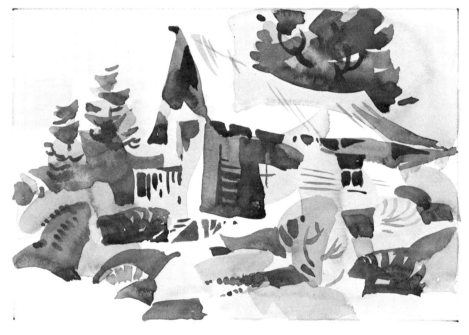

Diagonal Plan, Step 1. *This time, a more dynamic theme will be set up by diagonal patterns of well-scaled shapes. Color can be used selectively at this stage to indicate subject. However, don't overlook the need to organize the abstract balance of warm and cool throughout your composition. An all blue sky, for example, might set up a bold, cool note that would be impossible to counterbalance in the foreground.*

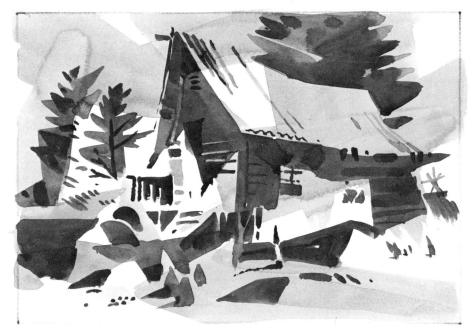

Step 2. *The shapes that build the subject will again be influenced by the underpainting. Notice the dramatic diagonal thrust in my example. Not only does the building coordinate with the underpainting theme of design, but the trees, sky, and foreground also fit the pattern. This dynamic design really needs the stability obtained by introducing a minor amount of static design. A right angle and a few verticals and horizontals are judiciously placed to build accents into and stabilize the composition. The curved shapes are selectively used to add further visual interest. Color in the underpainting subtly identifies the different areas. In the final stages add middle and dark values, using the bolder color to strengthen the description.*

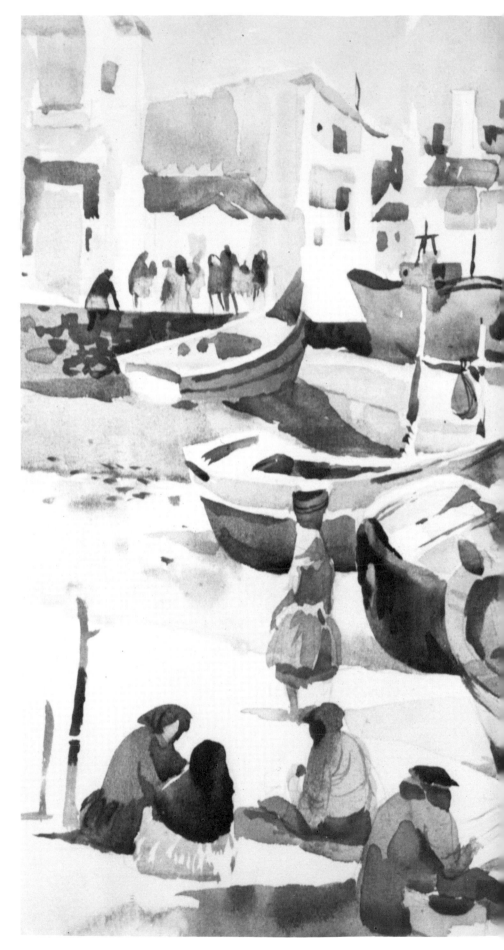

Nazare. D'Arches paper, 19" x 29". Life in this Portuguese fishing village centers around the beach from before dawn until dark. I sketched and painted there for three days, and this is one of the results. Notice the simplified handling of the figures. The seated group sacrifices identity, but not at the cost of character. These figures are painted with the same direct simplicity that I used in the boats and buildings. The distant lineup of people was handled intentionally in a lost-and-found manner to keep it from competing with major portions of the composition. The background buildings were designed in a similar manner for the same reason.

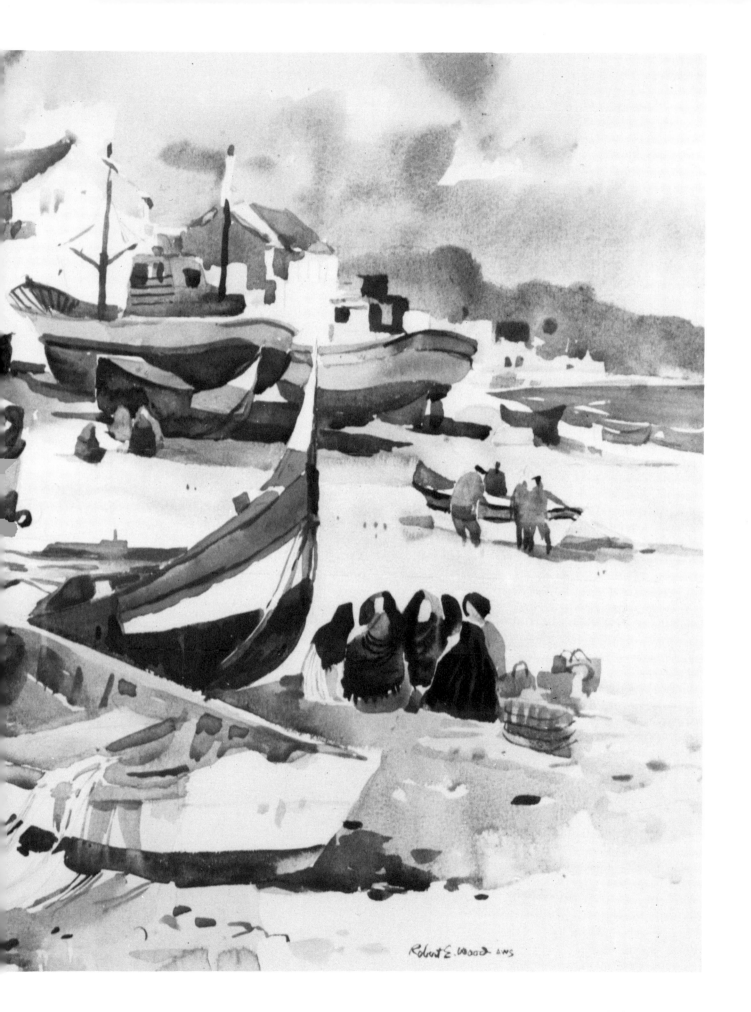

5.

Structured Middle Values

Peace People, detail. Linkage of the lights and darks were the designing tools used to turn these figures into interesting abstractions. Rather than painting each figure separately, I made a controlled pattern of light that flows from one person to another. Some dark portions of the figures are united to background darks. The final patterns achieved are more interesting than stark silhouettes would be, and they become a part of the rhythmic movement that unites the composition.

For the experienced painter, painting the first underlayer in a new watercolor with unworried freshness and sparkling color is easy. Finishing a watercolor by adding the "icing on the cake"—the final calligraphic lines and small color accents —is pure joy.

The real challenge lies in between these two stages of a painting. The structure of the middle-value shapes links the underlayer with the details and provides the bulk of the painting. Often one sees a watercolor with excellent underpainting overlaid by details. The entire body of the picture is missing and the final accents seem to float in space. This is like a story with a good opening, an exciting ending, but no content.

Painting Middle Values

The exercise that follows will give you the chance to do many small, trial-and-error versions of the same subject. You'll concentrate on developing strong middle-value structures, the necessary framework too often bypassed. In an effort to obtain a sense of scale and to permit an ease of passage or movement about the page, a linkage of subject-matter patterns is helpful. If you paint by the piece with a hard border around every section of your subject, you'll find that the overall design becomes terribly active and nervous in its edge qualities. To keep away from this problem of creating too many compartments, work with your big brushes and search for the pathways of linkage that allow the pattern to flow smoothly through the outlines of your subject. This linkage establishes a simple, calm foundation of middle-value patterns.

A light, balanced underpainting suggesting the basic divisions of space that the subject will occupy.

The final calligraphic rendering of detail describes the barn, trees, and foreground objects.

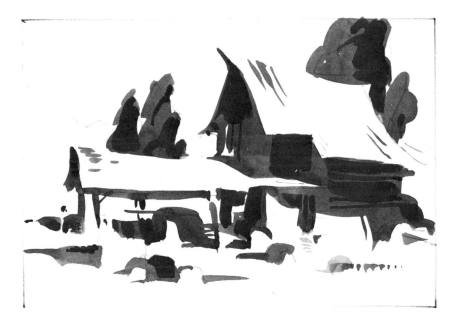

Together, the underpainting and final stage create a fragile result. The drawing floats on, but is not connected with, the underpainting. There are no substantial middle-value patterns to bind the painting together.

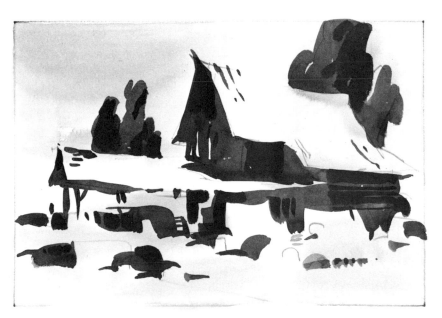

Here is an example of the
middle-value shapes that can add the
needed substance to the painting.

The same painting plan now has a
middle step added. This bold
patterning of shapes provides support
for the final drawing and smaller
accent patterns. I suggest "hanging
your drawing on a shape" by building
a range of middle-value shapes in the
painting. Then, when the final
calligraphic detail is painted, the result
will be a substantial watercolor with a
pleasing completeness.

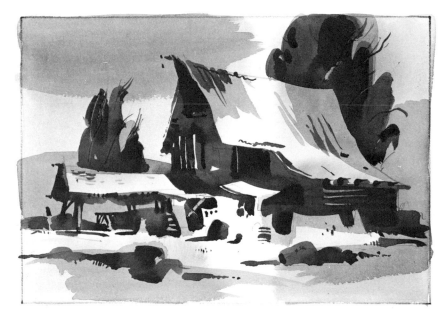

Exercise: Middle Values and Saved Whites

For this study you'll need 18″ x 24″ white drawing paper. I marked out my page with eight separate rectangles, each approximately 4½″ x 7″. You'll also need some waterproof ink or a felt marker, just one tube of color for the middle-value painting plans, and your Number 12 pointed brush. You may wish to try a smaller pointed brush for the original ink drawings.

The goal of this exercise isn't to paint finished paintings. Rather, you should do *many* thumbnail-sized plans that explore the different arrangement of middle-value masses. You should notice how a variety of shape impressions can be made with the same subject.

A good starting point in each new exercise is to plan and save the whites. In watercolor painting the white paper is a beautiful accent, so try to shift the display of lights in each drawing.

Step 1. *Use India ink and a small brush (or a waterproof felt-tip marker) to draw a simple plan of how your subject will fit on the page. Repeat the same plan in all eight boxes. There is nothing wrong with tracing the picture in each box if you feel it is necessary. However, it is quicker—and good practice—to duplicate the layouts freehand.*

Step 2. *With a large brush, paint some simplified, linked, middle-value patterns that will distribute and balance the major masses. In this exercise, the saved lights will be raw and commonly white, but in an actual painting they could include delicate variations in the underpainting. The dark accents and finishing details will come easily if the middle-value structure we are searching out is successful.*

Step 3. *Try another plan using different arrangements of these linked, middle-value patterns. Select a different set of lights to save. Keep it simple, and don't paint too many separate parts.*

Step 4. *Continue to fill your page with new experiments. Each new plan can explore a different arrangement of patterns that will search out new structural organizations. Do all eight of these exercises. It is interesting to see how changeable the major patterns can be although you are painting the same subject time and time again.*

Painting Problems:
Using the Middle Values

It's time to try a complete painting that attempts to make good use of the often-neglected middle-value structural organization. This will be a three-phase approach to doing a watercolor. The first phase will be the blended wet-into-wet underpainting that distributes the beginning color divisions and indications of substance in the various parts of your composition. Limit the darkness to middle value as you concentrate on the balance and scale of the total composition. Save a few choice lights to add sparkle to the final painting. The second phase will have the same goals as the previous exercises. Search for a bold structure of middle-dark value patterns of linked design that create a firm image on the page. These shapes are the building blocks that will support the smaller descriptive detailing of the final third phase.

Use a half-sheet of stretched watercolor paper, marked off into two 9" x 12" painting areas. A limited palette of yellow ochre, burnt sienna, and phthalocyanine blue—an earth yellow and red and a very transparent blue—is enough for a rich, full color painting. In addition, you'll need your normal working equipment—large brushes, water container, tissues, sponge, etc.

Use the other 9" x 12" space on your paper to try it again. Another of your exercises can be a guide for starting this second painting. Although the subject and the basic composition will be the same as before, pick an earlier design that makes a completely different shape statement from the first painting. It should be interesting and informative to see just how differently the same subject might be presented a second time.

A final hint about the importance of good value control: if your first painting turned out to be weaker in the middle values than planned, this is to be expected. The dampness of the page will tend to dilute the color you applied, and the color lightens as it dries. Plan to be a little bolder when you apply paint to compensate for the expected fading.

At this time value control is more important than color. However, this repeated study should help you to search out a variety of mixtures from the same limited palette. Save your purest colors for the final accents. The bulk of the page should have various degrees of color intermixings so a transition is established from the large, neutralized areas to the middle-sized and middle-rich pieces to the small accents of your cleanest pure color.

Step 1. *On one half of your stretched paper, pencil in a simplified composition plan of your subject. Your major concern should be the placement of the various parts of your subject matter, leaving refinements to be painted later. Dampen your paper, and immediately start painting in the first casual impressions of the local color using light to middle values. Paint out enough of the page to "limit the whites" to selected accent areas. Work quickly so all these shapes will remain soft-edged and undemanding. Value control is essential.*

SANTANA HIGH SCHOOL
LIBRARY

Step 2. *Now comes the supporting structure that is the real point of this problem. Using a big brush and deeper, middle-dark values of local color, paint a bold, balanced arrangement of linked shapes on the underpainting. Pick your favorite design plan from the previous exercise as a guide. Because the page is still damp, these shapes will be slightly diffused and soft-edged. You may find that you are having trouble making your shapes stay where you want them. To gain control, work with your board at a slight angle, not flat. Or try a thicker mixture of well-swiveled color in your brush so the moisture in the paper won't run away from you. This controlled handling of wet-into-wet might be better described as "drybrush into wet."*

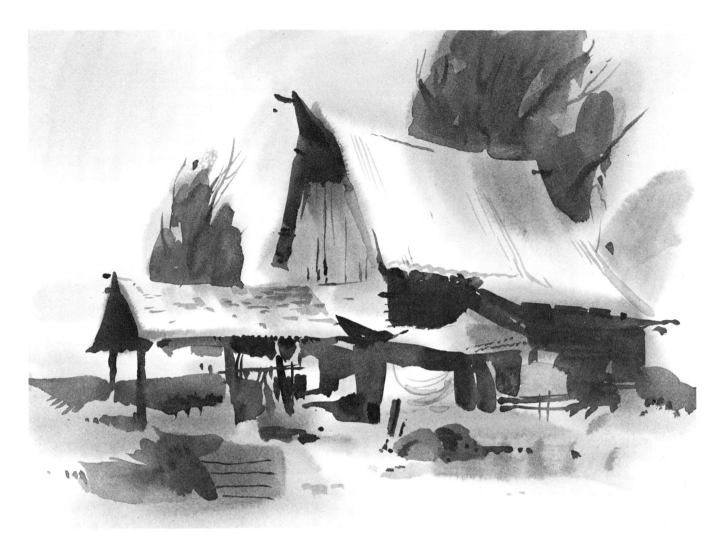

Step 3. As the paper becomes dryer, the firm, important "in-focus" shapes can be carefully introduced. This is the time to use your boldest darks and richest colors to paint calligraphy and details—the final touches to the subject. Remember, "hang" this information on the middle-value shapes you have prepared. Don't just float it out in the middle of the open space. One caution about the finishing process: Be careful! Avoid the trap of detailing every square inch of your page with equal love and tender care. There are important areas that need to be "turned on" with extra activity, strong value contrasts, rich color and hard-edge qualities, but many portions of the page should remain calm, softly diffused, and inconspicuous.

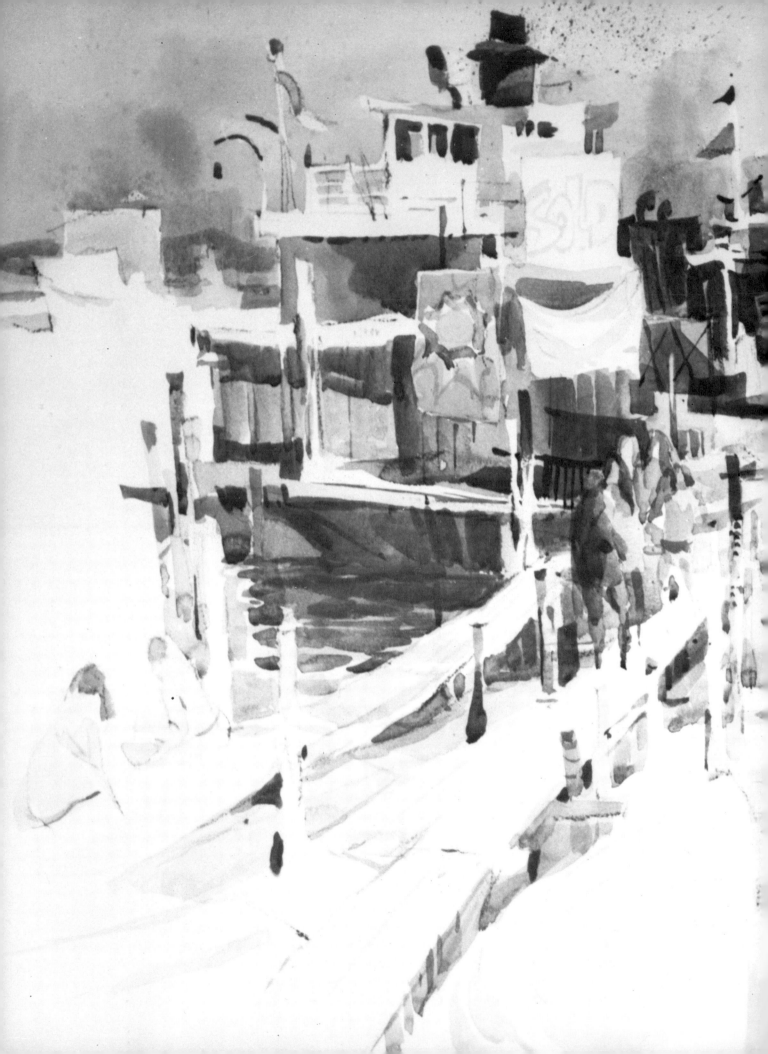

Sunny World of the Live-In Sculpture.
D'Arches paper, 26" x 40". The impetus
for this painting was a sketch I did while
flying home from a Sausalito, California,
workshop. The sketch gave an overall
impression of the wharves, boats, old
buildings, and rickety piers clustering
beside the bay. Structural interest
placed on the unusually high horizon
line makes this an intriguing
composition.

Rockport Shrimp Boats. *Cold-pressed paper, 14" x 20". This painting started with the glaze. I was concerned with the scale of the middle-value shapes I was painting and the lifting of some lights for dispersion of active interest around the sheet. As it neared the drying stage, I added the crisper shapes. Only then was I interested in bringing the subject matter into focus. The abstract design underneath and the techniques for creating a glowing surface were more important than the identification of a particular place.*

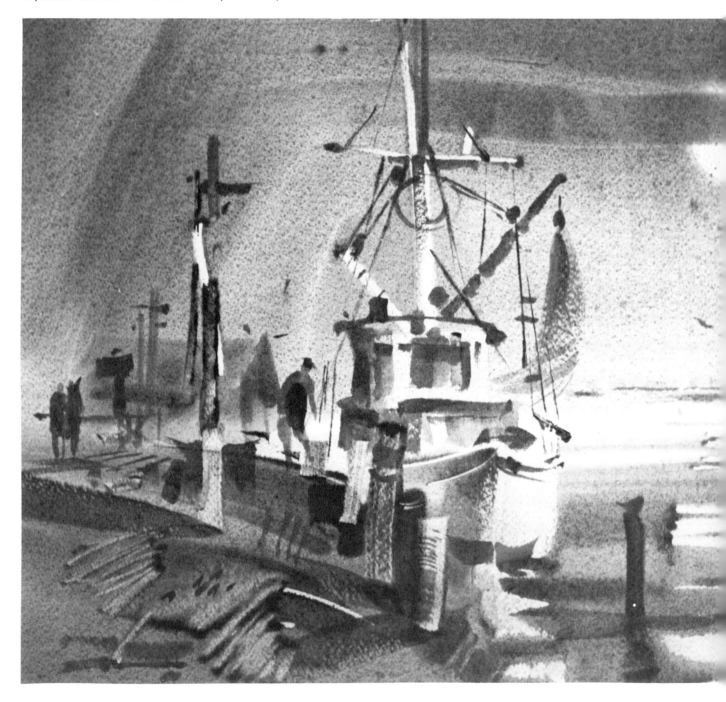

6.

Regaining the Lights

Contrast of light and dark is fundamental to art, for without it there is limited visual perception. With transparent watercolors light comes from the paper, not from white paint. Planning and saving the whites—planning to leave areas of bare paper—has been a valid and well-used method. A saved white is a beautiful, clean thing, but other kinds of light are also useful. Lights can also be brought back into a painting after the paper is covered with color—even color deeper than middle value. These lights have a different quality than saved lights, not necessarily better, but certainly handsome.

In this chapter both standard and non-traditional tools will be used to regain the lights. The watercolor brush, the stiff-bristled oil brush, paper napkins, blotters, matboard scraps, tissues, and masks made of file cards or credit cards all make possible tools for lifting off paint.

The following dry and wet lift exercises will be done on pre-glazed watercolor paper. The glazing of a full page has advantages beyond the opportunity to easily lift off color. It can create an overall color unity not easily attained when a painting is done one section at a time. It also establishes a glowing, unworried underpainting that enlivens the finished work.

These are exercises that should encourage exploration and experimentation; expanded control of standard brushes and different tools will lead to new creative results and greater excitement.

Dry Lift Methods

These first lift-off methods are free from the demands of time because you'll be working on a sheet that has a glaze already painted on it and is dry. The more opaque colors (such as the earth colors, cobalt blue, black, and the cadmiums) make good choices for the glaze. When the staining colors (such as monastral blue, phthalocyanine blue and green, and alizarin crimson) are used in heavy saturation, they don't lift off readily and therefore aren't recommended for these background glazes. With a little care, a variety of light areas can be created within the dry glaze using several lift-off methods.

Dry Lift with Large, Soft Brush. After glazing, carry a large, well-dampened brush to the dry page and wet the areas you

plan to lift. Clean the area slightly with the brush. Rinse out the brush and repeat. Give the dampened pigment time to soften, then rewet the area and lift again. When you have lifted off most of the pigment, quickly wipe the area with a tissue to prevent a watermarked edge. You'll find that a fresh, glowing light has been regained. Try a variety of brushes in this exercise. The 1" flat watercolor brush can lift out large areas as well as "stroke out" long, thin shapes when used with a light touch and moved side to side.

Dry Lift with Stiff Brush. An oil brush—perhaps a Number 8—with the handle cut down so it fits with other watercolor brushes, is one tool for this method. A small stencil brush with groups of bristles shaped differently at each end is useful for lift-offs, too. Using a light scrubbing motion, it's possible to wet an area, wait to give the pigment time to dissolve, rewet it, and wipe dry immediately with a tissue. For regaining a small, controlled area of light, this is a good method.

Dry Lift with Sponge and Masking. Soften an area with a damp, but not dripping, sponge. Give the pigment time to moisten and then lift off. A final quick stroke with a tissue dries the area and prevents a watermark. If you want crisp shapes, or shapes that are crisp on one side and soft on the other, little file card masks can be held down against the page. Use two cards to form a corner; sponge across this corner and lift off. Dry the area quickly and this will bring back nearly white paper. Other materials to use as masks are post cards, any stiff paper, or even credit cards. Also, paper can be cut to a shape and sponged along the edge or cut out like a stencil and sponged inside the exposed area.

Wet Lift Methods

We continue the search for new ways to create light. This isn't the time to record nature, but to expand your techniques so that you can *translate* nature through appropriate watercolor methods. Therefore, you shouldn't say to yourself: "How do I copy that sky? How do I recreate that shingle or tin roof?" Instead you might look up and think: "I can squeegee out that area and bring texture to life in a single, effective stroke. I can make the old wood surface happen by blotting. I can make that sun look softly luminous by lifting wet paint off with a soft brush."

I'm not prescribing formulas such as: "This is a sun stroke. This is a roof stroke." Instead, I'll be trying to help you enlarge your vocabulary of techniques. Your part is to adapt them for your own use. These lift-off techniques are presented one at a time and can be studied step-by-step. But remember, when you use them in paintings you should loosen up, experiment, and have fun!

Wet Lift with Brush. These techniques are done while the area of paint is still wet. Wash out a large 1" brush and thoroughly squeeze out the excess moisture. Then lift off a circular shape by siphoning—mopping the color from the chosen area as the brush is twisted and pressed down in a continuous motion. If the sheet is too wet, the color will flow back into the area you have cleaned. If the paper is too dry, no immediate lift-off will occur. The artist must learn to judge the timing of the wet lift-off. If the paper is shiny, but not *flowing* with dampness, surface color can easily be removed.

Wet Lift with Cardboard Squeegee. Cut leftover matboard pieces into little wedge shapes that have good, sharp, straight edges. With a clean, dry edge it's possible to pull a firm, single squeegee-like stroke across or down a portion of the damp page; this won't clean it to pure white, but will squeeze the color from the top roughness of the paper and create a light, textured area in the process. If some of the color at the base of the stroke puddles, don't worry; it will blend in with the surrounding damp color and won't look as obvious when it dries.

Wet Lift with Brush Handle. Using a brush handle (some are designed for this purpose), a knife, or the edge of a plastic spoon, firmly squeeze out the color from the page. With the tool held at a high angle, narrow strokes can be lifted off. When the tool angle is more horizontal, a wider stroke can be made. These strokes are very useful in "opening up" dark areas in paintings. Press firmly, but don't abrade the paper.

Wet Lift with Blotter. There are many absorbent materials —such as blotters—that can be cut or torn into shapes and placed directly on the painting to lift off wet color. Materials that have a pebbly-textured or patterned surface, such as paper towels or napkins, will leave some of their texture on the lightened area.

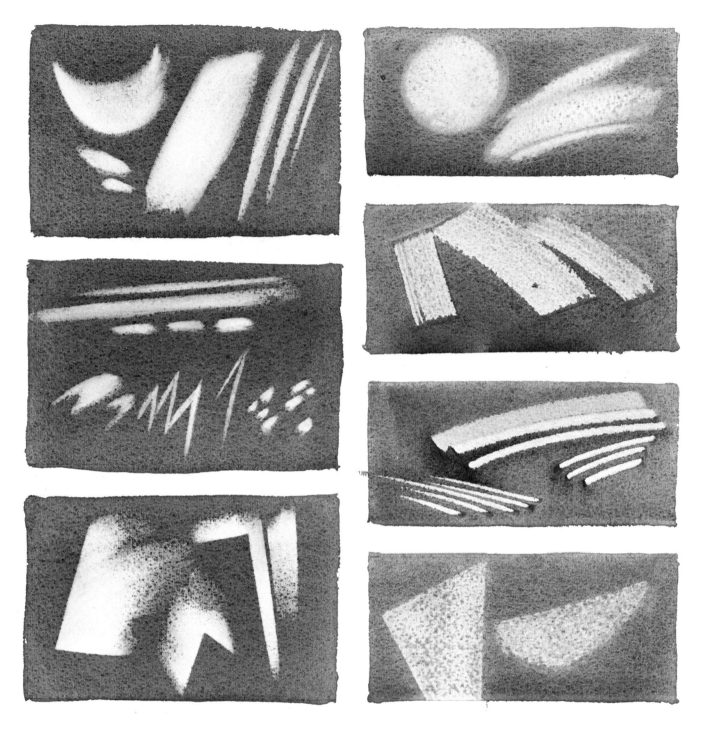

Dry-lift Techniques

Wet-lift Techniques

Exercises:
Practicing Dry Lift-Offs

Good paper is an essential element in the lift-off technique. A cheap grade of watercolor paper is usually soft, absorbs color more deeply, and cannot withstand scrubbing.

Stretch a half-sheet of 15" x 22" watercolor paper and mark off two 9" x 12" areas. You'll need a light yellow, orange, cobalt blue, and black colors. In addition to your normal brushes (Number 12 round and 1" flat) you'll need a small scrubbing brush (a stencil brush or a small bristle brush), a sponge, tissues, and some post cards or stiff paper for masking.

Step 1. Begin by laying a horizontal wash using a middle-light value of Winsor yellow that is more concentrated at the top and lightens as it flows down the page. This is called a graded *wash. Immediately lay a second graded wash, using an orange of middle-light value and keeping the page wet by working quickly. If one layer is painted over another that is still wet, the two will intermix spontaneously. I refer to this as "keeping the paint active." Keeping these layers still active, lay a bold cobalt blue wash, middle value, from the base up, followed by a black layer from the base up. You might find it easier to control these last two washes if you turn the board upside down and thin the washes slightly as they move down the page. Now let this glaze dry.*

Step 2. Using the dry, glazed sheet, try all the methods suggested in this chapter. Try lift-offs with a soft, wet brush, making sure to allow time for the pigment to soften; wet, rewet, and wipe dry. Use the stiff brush for smaller lift-offs. For straight-edged, firm shapes, use various materials to mask out areas and sponge the pigment off to regain glowing lights. Keep the shapes clean and simple. Later painting can strengthen the area. Right now, we are interested in regaining luminous light shapes.

Exercises:
Practicing Wet Lift-Offs

Good watercolor painting is always a challenge. I especially enjoy the battle that takes place when I face the problem of manipulating colors, values, and shapes on a wet page. Many exciting effects can be rapidly achieved when you're familiar with the mechanics of the medium. Try a squeegee stroke while the page is still too wet and the color rushes back into the area you had hoped to establish. Wait a minute too long and the color has firmed up so it's immovable. Judging the degree of dampness of a sheet is critical, and there is no way to master this exact sense of timing other than through experimentation.

You've read the instructions for several methods of lifting color off a still wet page. Now study all the information in the exercise; then jump right in and join the masses of frustrated watercolor buffs.

Wet Lift-Offs. Lay a graded wash with layers of raw sienna and manganese blue in middle-light valves. Keep the page active. Prepare all materials ahead of time. Cut up cardboard scraps into rectangles of different widths to be used in squeegeeing out color. Tear up or cut up some blotters, paper towels, and napkins. When the glaze is still in its wet stage –shiny, but not flowing with moisture– you are ready to begin. Use the brush lift and cardboard squeegee. Make narrow and wide strokes with the brush handle. Lay some simple shapes, cut from blotters and napkins, on the surface and lift off. Work directly with bold, single strokes. Remember: the goal is not to define the finished subject, but simply to pull back some glowing lights. Later on, when doing a painting, you can add middle values and darks that will define the light shapes, giving them an expressive character.

Painting Problem:
Rustic Cabin

Now you'll put the lift-off methods—wet as well as dry—to use in a painting project. It's important to know your subject well. I recommend that either you use the diagrams I'm supplying or choose a familiar subject of your own.

Take a look at my preliminary sketch nearby. It's a reference only—I'll do little or no drawing on the watercolor page. After developing the starting glaze, I want to feel completely free to design and adjust the distribution of the major light shapes that start the composition. These lights will be a variety of surfaces that are the result of lift-off methods. With middle values, dark patterns, and final color details, I'll further develop the light shapes while I'm paint-

ing. I think of this defining process in terms similar to sculpture — chiseling or carving away at the lights with darker surrounding shapes to give them their identity.

You can't put everything you know in one painting. Each painting is a translation of the subject—a simplified statement. The glaze beneath creates a unified color mood. To experiment with sparkling lights created in the lift-off manner is reason enough for starting a watercolor painting.

Know your subject ahead of time. Restrict initial drawing to a minimum, and let the structure develop during the painting process. Build some simple design shapes that give scale and balance to the middle val-

ues, darks, and lights.

Before starting to paint, read ahead and be sure you understand all the stages of the process. There will be times when you need to work quickly, and you have to know where you're going before you jump in. *Rustic Cabin* is 14'' x 20'', painted on rough, stretched watercolor paper. The glaze was developed with layers of raw sienna, manganese blue, and burnt umber. The over-painting was done primarily with the same three colors, but burnt sienna was added for extra warmth. Later on phthalocyanine blue was used to mix the transparent darks, and a sprinkling of other colors were added for the final, small accents.

Preliminary sketch for Rustic Cabin.

Step 1. *For the glaze, use either of the color combinations already explored, or better yet, pick your own for a new mood you want to express. Remember to start with one or two light-value colors underneath, then put layers of middle values over the top. (In my glaze I've used raw sienna followed by manganese blue and burnt umber.) This time, keep the glaze darker (a middle-dark value) at both the top and the bottom in order to enclose the subject. You're going to stage the major activity within these darker values, keeping the glowing parts inside and allowing less emphasis near the edges.*

Step 2. *Immediately work in some large shapes of middle and soft, middle-dark value–the upper sky, the foreground shadows, a portion of the wooden cabin, and the background trees. Local color identity can be expressed at this time. Paint the sky a different color from the cabin. The roof can hint at a color of its own. Identify trees and foreground as slightly individual color notes. Strike these things in while the page is still damp. The soft shapes will give the painting weight and bulk. Keep it simple. The details will be reserved for later.*

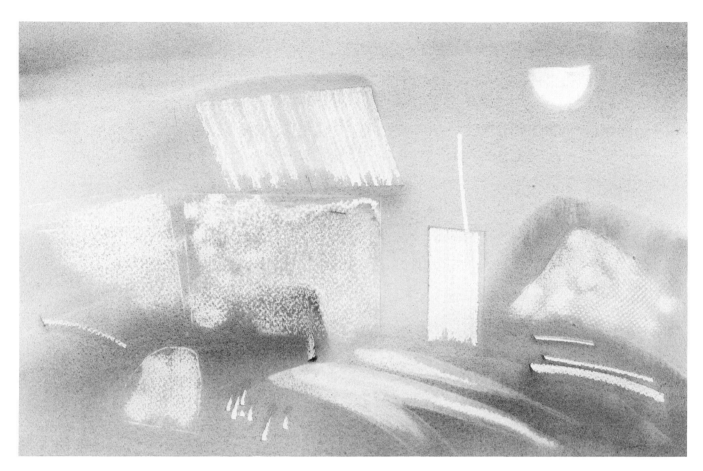

Step 3. Work quickly to explore some simple wet lifts. Before the painting has a chance to set, you can create the circular moon shape with a brush lift. Squeegee out a roof area, a portion of the building, and some of the hangings. Don't try to finish these areas, but develop a balance of lights—a group of lights that distributes interest around the page. From the largest area to the smallest, these lights will be scaled in size and distributed through the painting to create both interest and contrast.

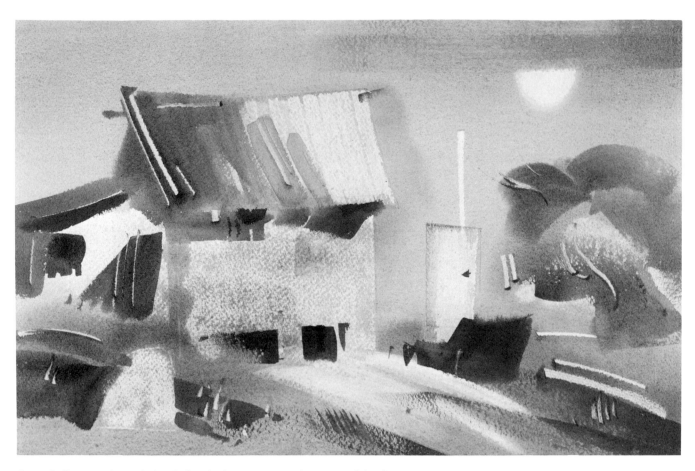

Step 4. By now the painting is beginning to set, and you can introduce some structural, firm darks. Paint linked shapes of a middle-dark value to add weight and mass to the painting. These shapes will identify the character of the subject. Rather than finishing each part, try to balance these new weights throughout the picture. Later, you can hang the details of the various surfaces on these dark shapes.

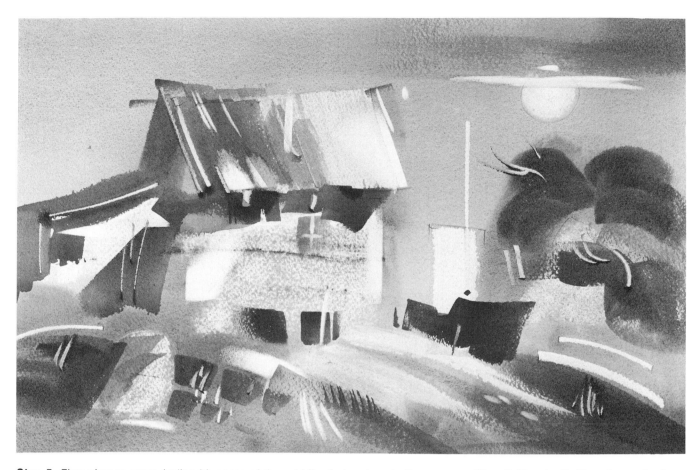

Step 5. *Firm shapes were built with some of the middle-dark values in the previous step. Now, use dry-lift methods to search out crisp, light shapes that can strengthen the subject and balance the final glow of light throughout the painting. The painting is dry, and you can take all the time you need to plan these last stages. Keep the lift-offs simple, and limit them to three or four choice areas, (for example, lighten an edge of the building to separate it more clearly from the background). Respect the tenderness of the paper; try not to scrub these surfaces any more than necessary. Later you can do a small amount of fresh brush drawing in portions of these lifted lights, blending them back into the painted sheet. The lifted light areas should function as integral parts of the painting rather than unrelated afterthoughts.*

Step 6 *(Overleaf). Now the rush of emotional work is over, and it is time to finish the painting. Not every portion of this painting is of equal importance. Some parts need to stay out of focus, semi-finished, so they don't compete with the major areas of design. Try to finish a painting just like a good golf game, with a minimum number of strokes. Selectively distribute interest-catching areas of activity, both dark and light, as well as richness of color and detail around the page. Do not fill every square inch equally with refinements. A limited amount of bold detail—colorful, transparent, dark accents—and informative drawing will make your painting sing with vitality.*

SANTANA HIGH SCHOOL
LIBRARY

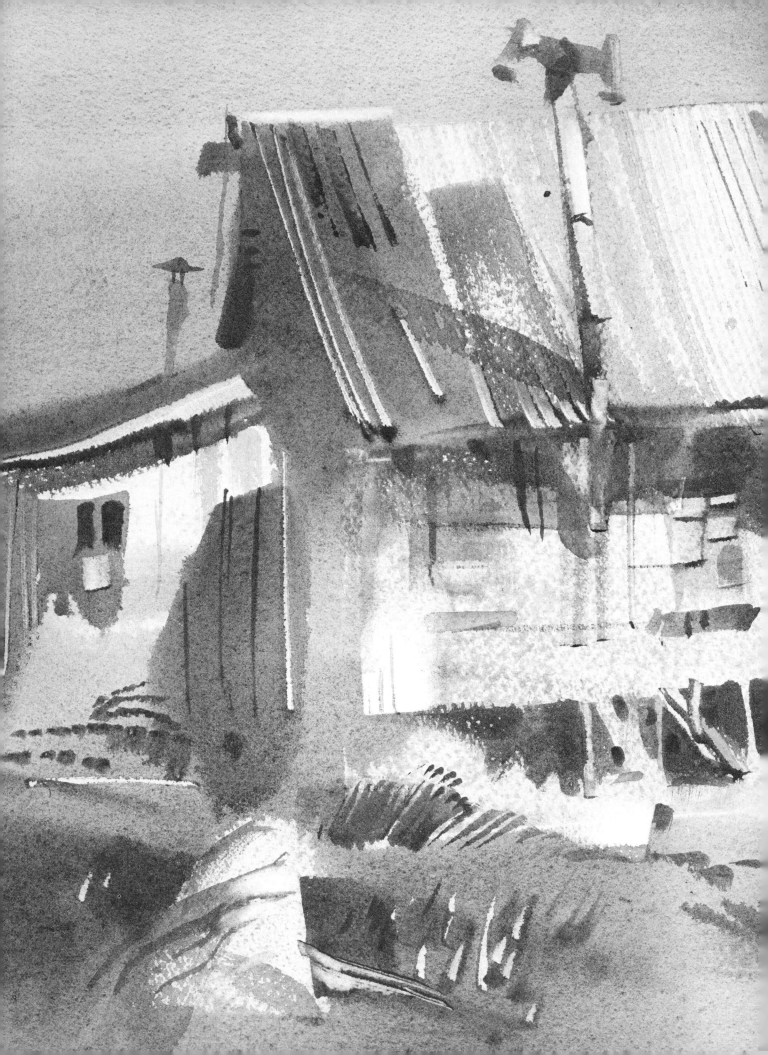

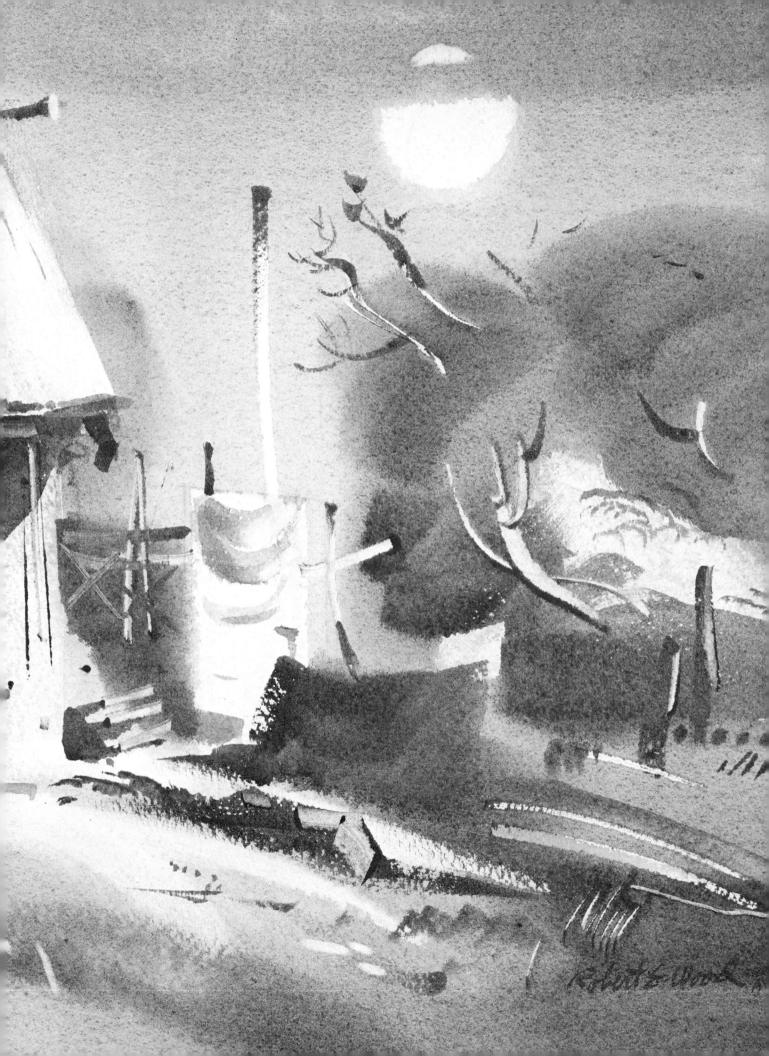

Figures in the Trees. Aquarius paper, 22" x 30". This painting began with a "discovered composition" as a foundation. The subject matter is superimposed over it with inventive, firm design control. I believe most students have a good sense of design, but it can be easily overpowered by the demands of rendering a subject. This method of painting—starting with a well-organized nonobjective underpainting—releases the natural command of design controls. With practice, this command can be maintained in the overpainting when subject is added.

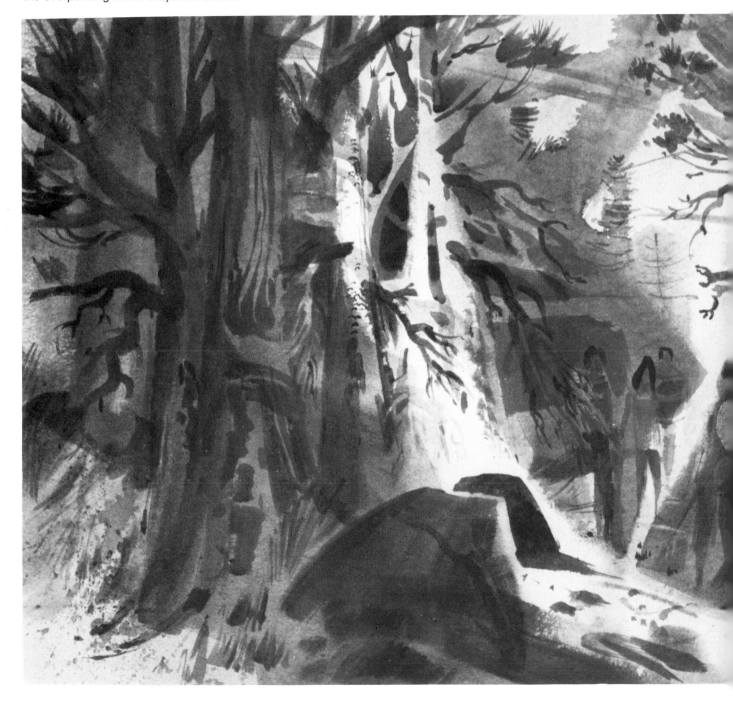

7.

Dramatic Staging

The normal value range is one in which the bulk of the painting is enveloped in the middle-light to middle-dark values. They further a painting's sense of structure and mastering this normal range of gutsy middle values is basic. Accents of whites and darks are added later for boldness or sparkle.

In this chapter, however, we'll explore arbitrary uses of value purely for dramatic effect.

A Key to Value Control

The illustrations on the next page show the changing moods that can be expressed by different value limitations.

Normal Value Range. The majority of this composition is covered by middle-light to middle-dark values. This allows the whites and final darks to both be important accents. To coax you out of the normal range, however, study the values shown in the other three illustrations.

High-Key. This airy, light painting includes nothing too dark or bold, but it isn't wishy-washy. Structure is strongly delineated even though the painting is still reserved in effect. The choice of interesting colors arranged harmoniously—warm against cool and rich against neutral—and the restrained use of darker values are points to consider in planning the high-key paintings.

Low-Key. A low-key plan could be totally dark, but I've instead devised a painting that is, in effect, *forcing the lights*. By painting the bulk of the page darker than middle value and surrounding the few saved light areas with rich darks, attention is dramatically directed to the lights. To subdue the shocking quality of the accents, which might seem to jump off the page, it's helpful to let portions of them soften and gently blend into the background darks.

Middle-Key. Boldly contrasting colors and rich colors against neutral ones of almost equal value can result in a dramatic, middle-key painting. All pure whites are painted out, and the entire range of values used is in the center. The needed contrasts are formed by pitting cool against warm and brilliant against dull. It's in this type of painting that the *magnetic* design element is most important: vibration and glow come from the intense purity of color competition. Experiment with the strong contrast of complementary colors—blue against orange, red against green, etc.

Normal Value

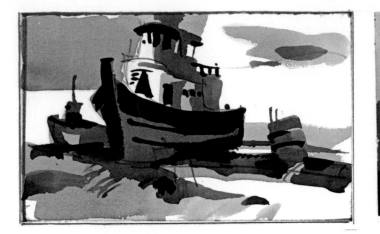

High Key

Low Key

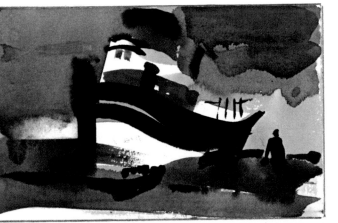

Middle Value

Exercises: Colored Value Plans

On 18" x 24" inexpensive white paper, make four full-color thumbnail experiments of a subject you know well. I'm using a new subject (an adobe church at Golden, New Mexico). I'll be exploring restricted value and color controls to obtain a range of strikingly different effects. Mark off your paper in 7" x 10" areas, and use a full range of colors along with your normal watercolor equipment.

Using the following illustrations as examples, paint (1) a normal range value study, (2) a high-key plan, (3) a low-key plan (that will force the lights), and (4) a plan using only the middle range of values.

Notice the changed mood in each of the paintings shown. Besides being four versions of a theme, they're really four separate paintings, each exciting in its own special staging.

The painter has the tools to spotlight, to dim, to flood with light, and to darken all at his command. Like the theatrical director and the movie maker, the artist creates a mood with dramatic control of light. The artist has power not just to record nature but to create a work of art. The more he becomes aware of his power and exerts it, the more creative his work becomes. Throughout this book, the emphasis is always on the creative power of choice that rests with the artist.

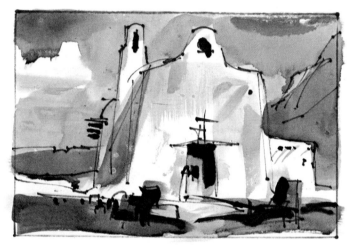

Normal Value. *Use a full range of values. Pure lights and richest darks should be kept to a minimum; they are the accent tools of this plan. The bulk of the composition will be painted in the middle range of values.*

High Key. *Keep your tones lighter than middle value in this study. Patiently experiment with the development of interesting color qualities. Start with clean, glowing color and then neutralize some areas by overpainting.*

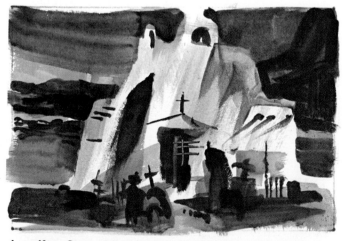

Low Key. *Start with at least a middle value and paint out most of the page. The few saved lights will be dramatically spotlighted. Use your most transparent colors for the middle dark and darkest shapes. Soften an edge or two of your harsh light patterns to blend them into the painting.*

Middle Value. *This whole composition should be built out of near-middle values. Color will obviously be your strongest tool for creating the needed contrasts. Experiment with the strong clash of complementary colors—warm against cool and rich against neutral.*

Painting Problems: Value for Dramatic Effect

On good-quality watercolor paper, you'll now paint four half-sheet paintings that will be carried to the finished stages. Again the illustrations shown are to serve as an idea stimulator for you. I'm using the same basic subject again, and I plan to use what I learned in doing the exercises, but these will be completely new paintings. New shapes will, of course, evolve in doing these bigger paintings, and interesting, unusual color may develop. Instead of merely copying a previous plan, I'm going to keep alert, cooperate with what develops on the page, and try to really become involved with the creative aspects of this exercise in disciplined color and value control.

Each problem will be a half-sheet painting, 13½" x 20". I have worked mine on 140 pound d'Arches watercolor paper that I stretched ahead of time. If you're used to working on unstretched paper, fine. I personally enjoy painting on a sheet that stays perfectly flat no matter how wet I get it. You'll need a full range of colors on your palette plus your regular working equipment.

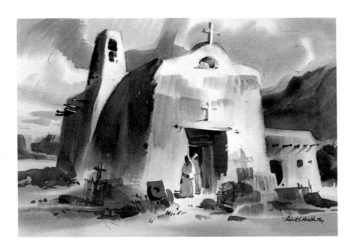

Normal Value. *Cover most of the page with light values that cut around and save an apportioned selection of whites. Next, paint large shapes of middle and middle-dark colors that will build structure. In the final stage, you can carefully paint a few rich darks and color accents.*

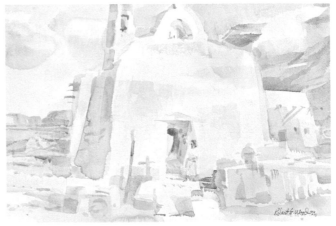

High Key. *Try painting with clean, sparkling colors, all lighter than middle value. Gradually overpaint these shapes with other pure colors, warm over cool and cool over warm, and see how the page begins to glow. Some areas of neutral color will eventually occur due to overpainting.*

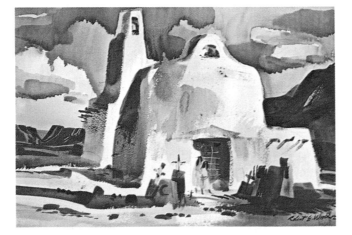

Low Key. *This will be an almost totally dark painting, middle value and darker, to force the lights into extremely powerful accents. A luminosity can be achieved in these dark values if you choose your most transparent colors. The saved, light areas need to be designed and distributed carefully. When nearly finished, (develop a transition from the whites into the darks by softening a few edges.*

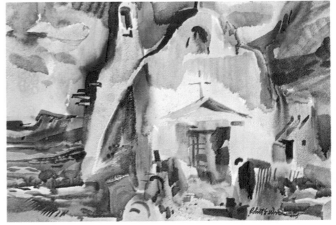

Middle Value. *Color is the basic designing tool in this painting. The value contrasts are limited, staying within the middle range. I tried to use bold, complementary colors that would scream against each other. To alleviate the raw brightness of too much pure color, I also used some calmer, mixed neutrals. These subdued areas help to make the painting rich, not just gaudy. The final mood is zingy and tropical with plenty of verve.*

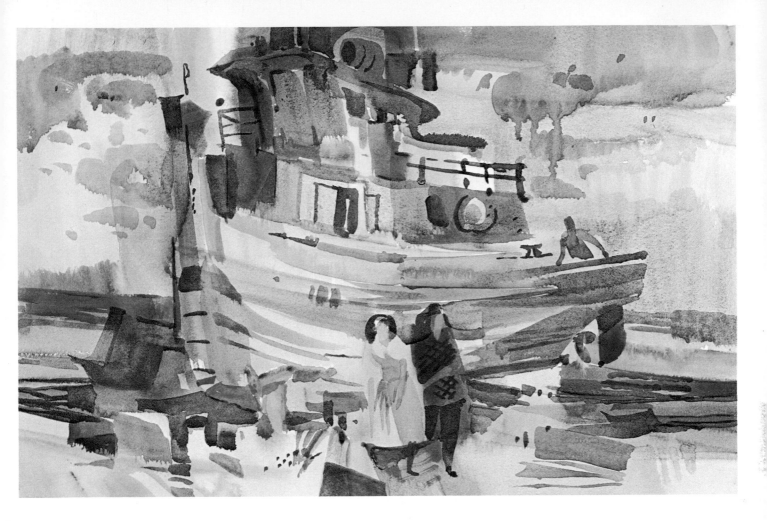

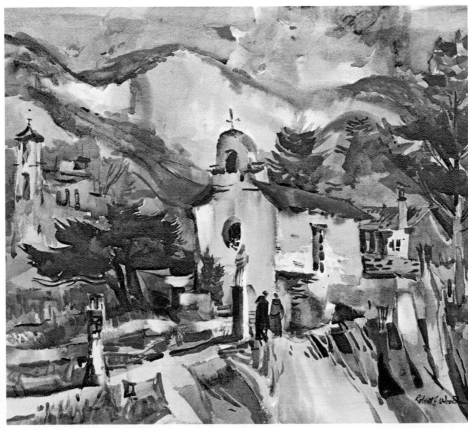

Texas Tug. *D'Arches paper, 13" x 20". In this painting I was forced to explore unusual color qualities because I set a restriction on the value range before I started. This is an example of the middle value plan discussed in this chapter. With contrasts in the work so intentionally limited, I was forced to explore other means of giving the page structural substance. Color became the tool—and a very dynamic statement the result.*

Mission at San Jose Creek. *D'Arches paper, 22" x 30". Here again is a subject painted within specific value limitations. I did full-color thumbnail studies first, trying a normal-value range, a high key, a low key, and a middle-key plan. Each plan offered good possibilities, but the middle-value plan seemed the most exciting.*

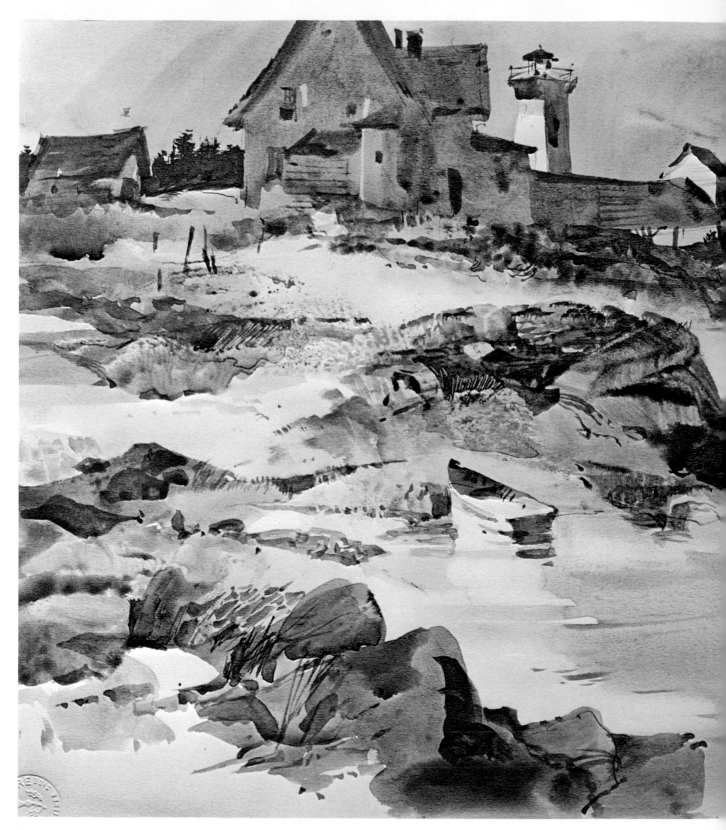

New England Light. *Bristol board, 11" x 14". The slight tooth of the board allows different textural possibilities than the rougher watercolor papers. The identity of individual brushstrokes and stamping textures stays in focus on this sheet. It is hard to achieve smooth washes, but if you work directly—trying to strike things in with the correct value and color the first time—the painting glows with an intense vitality.*

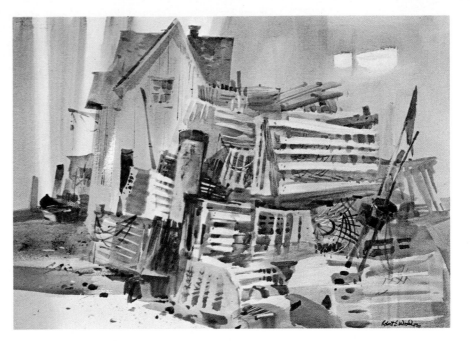

Lobster Pots at Motif 1. *D'Arches paper, 22" x 30". This is the final painting done as a demonstration for a painting workshop. I used a finder mat to discover a composition in a magazine. After pasting it on a card, I tacked it to the top of my drawing board and painted the nonobjective underpainting. I then let the class choose which side it wanted "up", and proceeded to do the painting from memory of my earlier paintings and sketches. Motif 1 is so named because it has probably been painted more than any other location in the nation. Using an arbitrary underpainting provided the unique composition that, I feel, makes this an interesting version of a very tired theme.*

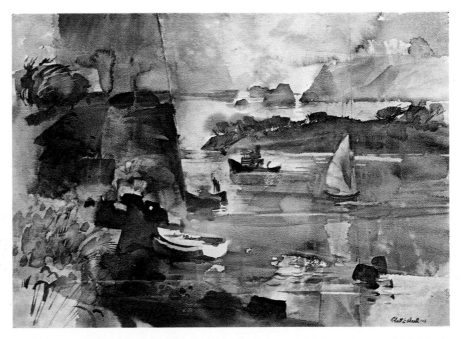

Northwest Inlet. *D'Arches paper, 22" x 30". I used 140 lb. paper, and I folded and crumpled it before painting. This is a powerful way to create patterns that are useful, different, and not possible with standard brushes. While the full page was wet and the design still tentative, I folded the sheet back on itself to provide more patterns. Using middle values, I began suggesting the subject, and then finished with darks, and color accents. Before the page dried, I stretched it flat on my board.*

Pier A. *D'Arches paper, 22" x 30". Exciting areas were created in this painting by lift-offs, stampings, and spatters. They symbolize the different surfaces and types of material, and they give them their character. Unorthodox tools can be used for a wide variety of textural effects. The challenge is to apply them selectively—balancing textured areas against restful plain ones—and to keep the total effect in mind.*

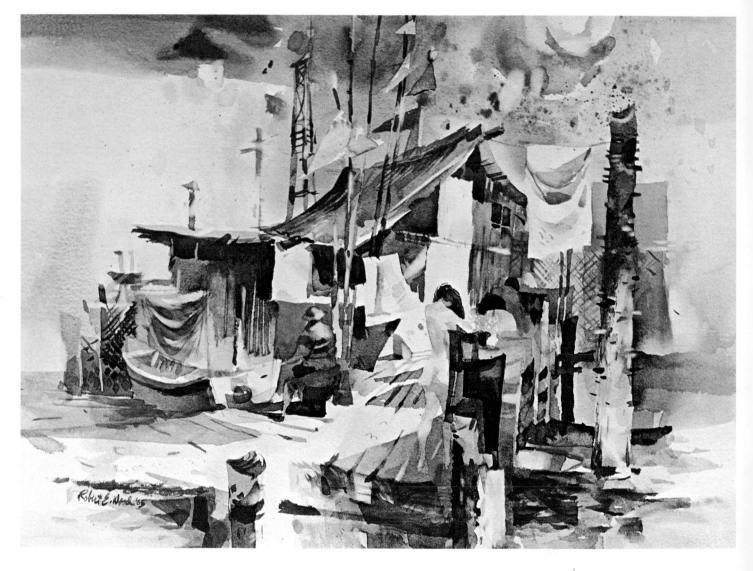

8.

Surface Variation

Brushes are but one tool for the watercolorist. A creative artist can achieve interesting effects with salt, a blotter, a brayer, or a limitless number of other materials. I use many means and methods to control the flow of pigment and water on paper. However, I don't think of them as tricks that guarantee successful results. My aim is to paint a variety of textures on the picture surface in distinctive and pleasing contrast to normal watercolor effects. Enhancing the surface creatively adds a subtle, personal quality to a painting.

Anything Goes

In this chapter, I'll introduce a free-wheeling, anything goes attitude toward the possibility of painting with "foreign" materials. You'll be given a technical exercise—with illustrations of varied textural effects and the methods used to achieve them—to suggest ideas for your first experiments.

The painting problem that follows involves the use of inventive textures with a conscious purpose. The final surface variations will be practiced effects that attempt to evoke an intriguing range of tactile sensations. I enjoy freshness and vitality in a good watercolor painting, and these techniques can enlarge your command over the medium and provide a quality of "controlled casualness," and not just happy accidents, that can add new life to your work.

Exercises: Discovered Patterns

Use stretched paper of good quality—either two half-sheets or a full sheet. Each experiment will be done on an area approximately 4" square. Use any color you like, but remember to select the less staining colors whenever you plan to *lift* pigment off the page.

Read through the instructions that accompany the illustrations, then gather the materials you'll need. When you're ready to start, draw some strokes and

Crayon Resist. *White and colored crayons can be drawn on the page. The wax will resist the watercolor wash that is painted over it, letting the crayon show through.*

Blooms, or Waterspots. *Touch water into barely damp areas. As the page dries these waterspots enlarge and form interesting patterns. Clear water can be sprinkled, dropped, or brushed on the painting.*

Tissue, Paper Towel, or Napkins. *These materials can also serve to lift out paint. Each one leaves its unique pattern. The materials can also be crumpled for still different textures.*

Squeegees. *Using cardboard scraps or credit cards, firmly drag pigment from an area of the damp watercolor page. It will leave a lightened area with some paper texture showing.*

Cardboard Stamping. *Apply paint to cardboard scraps of different shapes and textures and then stamp these into wet or dry areas. This will transfer impressions of the paint patterns.*

shapes with both a light and dark crayon in your first work space; then cover the space with a bold wash of middle-dark value. You're on your way to experiencing some different creative watercolor techniques. Try as many of the suggestions as possible, and more important, invent your own methods of applying and lifting color. There are no rules, so feel free to experiment. The goal of this exercise is to teach you to be inventive, not just to memorize a few strange methods of applying watercolors to paper.

Sand and Gravel. *These nonabsorbent materials sprinkled on a wet wash will gather concentrations of color around each spot of grit. The loose material can be brushed off after the page is dry.*

Brayer. *Paint can be applied to a brayer (an inking roller), perhaps in several colors, and then rolled on wet or dry paper. Try just a stroke or two. Continued rolling will mix up a layer of muddy color.*

Toothbrush Spatters. *Scrub a damp toothbrush into pure pigment. With your thumb, pull the bristles back and spring color toward the painting. Mask areas with cards or cut paper to control the shapes of the spatters.*

Clean-Water Spatter. *Fling clean water droplets off the brush or fingers onto the painting. Different effects result from damp versus nearly dry paper. If the page is very wet, nothing will show for your efforts.*

Blotter Lift-outs. *Blotters can lift paint off a damp watercolor. The texture of the blotter will show on the paper. Try leaving the blotter down for different lengths of time. Try a little pressure; try a firm blotting.*

Other Stampings. *Paint can be applied to a leaf and then pressed on the painting. Try stamping with a spool, the end of a pen cap, or an eraser.*

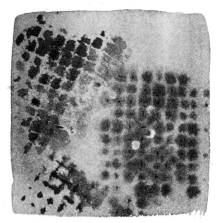

Screens. *Paint can be applied to a piece of wire screen and then stamped on a painting; or paint can be brushed through a screen placed on the painting.*

Salt. *Salt can be sprinkled on a moist area; pigment will be absorbed by each grain. When the paint is dry brush off the salt–the crystalline patterns left are that of snow or rain.*

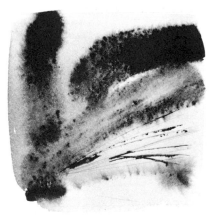

Palette knife. *A palette knife can either dab or drag pure pigment on wet or dry paper. The edge can be used for creating very thin lines.*

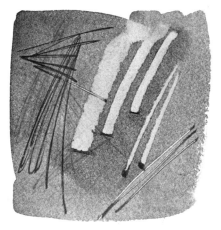

Brush Handle. *The chiseled handle of a flat watercolor brush can be used to scar or distress the surface of the page, either just before painting or while the area is still wet. This will cause dark markings.*

Sponge or Brush. *Wet paint can be lifted off a page with a damp brush or sponge. Soft patterns of light shapes are the result. Thick pigment can be applied to the brush or sponge and stamped on the paper also.*

Painting Problem: Displaying Textures

Having completed the exercises, you've probably found that it wasn't too difficult to invent new ways of applying paint to paper. The range of different effects that can be discovered is unlimited.

Now it's time for the most difficult challenge: using some of these new methods in a well-organized painting. When an artist is first presented with the textural possibilities of watercolor, he sometimes goes a bit overboard. Textural variations can be exciting, but throwing in a little of everything never leads to a satisfying result. So the first concern is to limit the variety of contrasting surfaces—saving some plain spaces, building some delicately patterned areas and some strongly patterned ones. This is more important than seeing how much dramatic activity you can force into a single composition.

In this problem you won't be able to predetermine what the finished painting will look like. You'll be experimenting rapidly with the scaled display of interesting textural surfaces. Don't worry ahead of time about specific subject matter. Instead, think *scale*—big, middle, and small. Think *balance*

—warm-cool, dark-light, and textured-plain. Trust your design instincts as you quickly develop the whole painting surface.

At first you should be at liberty to freely invent and distribute the surface variations without restrictions. Again, the major goal is the abstract relationships you establish with your inventive applications of textures, scale, balance, distribution of calm areas, slightly active areas, and emphatically patterned ones. Set these accomplishments firmly in your mind. Turning this underpainting into identifiable subject matter becomes simpler than you might think if the abstract organization is a satisfying display in itself.

Enough of this mental preparation. Let's get on with the painting fun! Stretch another half-sheet of watercolor paper and get your full equipment ready. Gather implements for creating textures (more than you'll possibly need) so they'll be handy when and if you get the urge to use them. Read through all the steps in the examples shown, and thus prepare yourself to work without hesitation.

Step 1. *Paint a simple underpainting to support the textural experiments to follow. You can start with a random wetting of most of the page to provide some soft and crisp distribution. Then use your big brush (at least a 1" flat) to build a static foundation of shapes no deeper than middle range. Color should convey a feeling, a mood, rather than the actual facts of nature. Forget about blue skies and green trees. Paint the warmth of summer, the cool of an evening light. Let color play a symbolic and abstract role, just as the textures will when they eventually suggest things.*

Step 2. *Now try your textures. Don't wait for the underpainting to dry–jump right in. Be daring–explosive–emotional–inventive. There are some important goals and controls in this freewheeling phase, however. Pay attention to scale, balance, and the distribution of some plain areas. The textural applications can be delicate in color or strongly contrasting. Their size can range from tiny to large, and they can be dry and crisp or diffused. Get these design and organizational devices well in mind before you start.*

Step 3. *When you start to paint subject matter, you should keep some new goals in mind. One, obviously, is to start identifying things, and another is to simplify the composition. The experimental page is terribly active. Now you should pick and save a few of the textures, and make them effective by painting out some of the surrounding activity. Suggest the first impressions of what your subject might be in an incomplete, ghostly manner. Sponge out other areas if it improves the balance and distribution of the restful areas of the composition.*

Step 4. *As the painting continues, refine the lost-and-found quality. The subject matter has been gradually developed until it has a substantial sense of structure. Areas that seem too busy are either painted over or lifted out. A few selected areas of really beautiful texture are saved and enhanced with surroundings of glowing darks and simplicity. Final details and richest colors notes finish the painting.*

Summer Solstice. *Drawing paper, 18" x 24".*

New Mexico Church. *D'Arches paper, 13½″ x 20″. I'm using a subject that I now know quite well (see Chapter 7). This painting points out again that doing a subject once does not exhaust its possibilities. There are many good reasons to return to a theme. Notice that the structure of the church does not strictly fit the underpainting. It can jog the underlying patterns freely and still record as a substantial structure.*

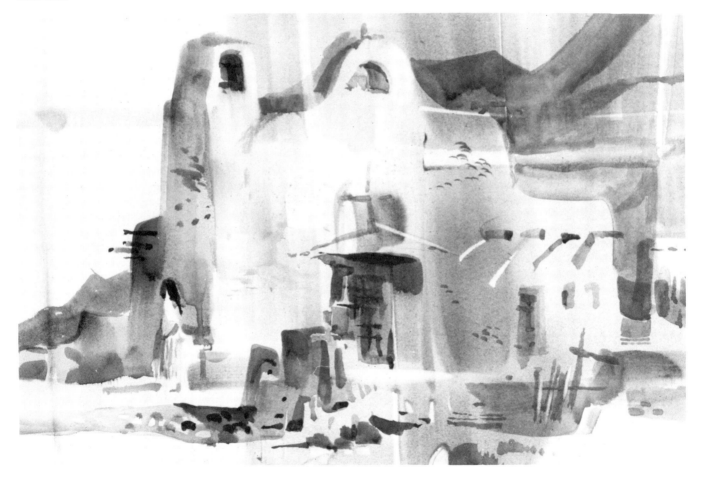

9. Abstract Underpainting

I could begin a watercolor painting with a detailed drawing, and when I'm just getting to know a subject, I often do begin this way. It's the usual approach in an artist's early career. But with more experience, the artist organizes his subject matter, and in effect, abstracts from nature to create a composition of good design.

I find it equally valid to begin a watercolor with a nonobjective statement of shape, space, color, and textural order —almost disregarding an eventual display of subject matter. Only after the abstract underpainting is organized to my satisfaction do I bring the subject into focus. This is the approach I want to demonstrate in this chapter.

In the technical exercises we'll first search for a nonobjective composition, then recreate it in an underpainting. In the painting problem, we'll add subject matter to a nonobjective composition.

A picture magazine and an adjustable mat are used to discover a variety of nonobjective composition plans.

SANTANA HIGH SCHOOL
LIBRARY

Exercise:
Finding an Abstract Design

This exercise will deliberately avoid reference to subject and instead look for satisfying abstract compositions.

You'll need a picture magazine or two that you're willing to cut up and discard. You'll also need to cut two small "L's" made from stiff paper or file cards (approximately 4" x 6"). These mats will be used as a viewer to search out small portions of photographs that display pleasing compositions. You won't be looking for identifiable things. The search is for nonobjective arrangements in space that are satisfying and interesting.

A unique pattern, an arrangement of scaled shapes with unusual character and balanced light and dark elements can be discovered in this manner. The little compositions should be cut out and pasted on file cards to serve as plans for later abstract underpaintings.

Don't worry if you feel unsure of your selection of compositions. Cut out several possibilities and paste them down. After you've collected about a dozen, you'll see that you have discovered a few you like better than others. That's the start you need.

A Search for the Abstract. *Move the finders around on a photograph until you see a dramatic composition you like. Cut it out and paste it down on a 4" x 6" file card. You aren't looking for subject matter. Scale, balance, containment, and interesting textural variety are the goals to keep in mind as you choose these nonobjective compositional plans. Prepare several of these studies for use in the next exercise.*

Exercise:
The Abstract Underpainting

An underpainting is just that —an organized layer beneath the subject. It gives the finished painting both design and color organization. The underlayer shouldn't compete with the subject, so there are some limitations to observe. It would be wise to use a wet-into-wet technique, and keep it soft and diffused. Crisp, in-focus shapes will be reserved for the second half of the painting process when the subject is developed. Limit your underpainting to light and middle values. Save your middle-darks to darks so you have their punch available later when you force the subject. Set up an arbitrary color mood. Play warm against cool, letting one be dominant. Scale, balance, containment, and textural variation can be freely interpreted within the above limitations.

Above all, remember what I tell myself before I begin a painting: K.I.S.S.—Keep It Simple, Stupid! It's especially important to keep this underpainting simple because more activity is to come when the subject is introduced.

You'll need two or three stretched half-sheets of good watercolor paper for this exercise, a full palette, and complete working equipment.

Step 1. *Pick one of your favorite "discovered design plans" for a guide. Decide which side you prefer "up" and then, on your stretched watercolor paper, pencil in the big shape distributions it displays.*

Step 2. *Now paint the space, shape, and textural relationships of your small plan. Start on a dampened page with a middle-light value. The whole underpainting should be completed in hues no darker than middle value. Concentrate on saving the lights and striking in the large areas of delicate values. Keep the underpainting soft. Work quickly so you can get the composition plan down before the page dries and the shapes become too firm edged and important. Use color in an arbitrary rather than identifying manner to produce the mood of your choosing.*

Step 3. *Use your middle values to finish the basic underpainting, and add a little final color excitement now also. Do this phase just before the page starts to dry and your underpainting will have the design organization you like — one subdued enough (limited value contrast and soft-edged shapes) to be later overpowered with richer colors, stronger darks, and hard-edged forms.*

Painting Problems:
From Abstract to Nature

Each time I do a watercolor that starts with a well-organized abstract underpainting, I'm surprised at how successfully these nonobjective patterns seem to work with the superimposed subject. Not only do the arbitrary shapes seem to coordinate well, but even more importantly, the patterns underneath provide a unity of design that makes the whole painting easier to bring to a successful conclusion.

When you've finished the first painting, stretch another half-sheet and develop a new underpainting design. This time try an abstract underpainting plan of your own design (without using a clipping). An interesting combination of soft and crisp shapes can be developed by a random partial wetting of the paper just before painting. Again, don't let the subject influence you too strongly at this early stage. Most important is the goal of establishing a shape, value, and color statement that is a pleasing organization in itself. Value control, softness, balance, color mood, and containment are the objectives. Be alert to what develops on the page, and mold a composition that you like for itself. As the underpainting begins to work, move right into the subject, defining it with your darker values and firmer shapes.

Step 1. Develop a new set of discovered composition plans with your mat finder. Pick one that you like for this painting problem. Don't be overly concerned with thoughts of future subject matter at this stage. It's more important to search for a scaled display of shapes that creates a unique balance and distribution of activity throughout the painting—an arrangement that is interesting in itself.

Step 2. *Now do another half-sheet study on good watercolor paper, stretched, using a full palette of colors. Decide on the general color mood you wish to develop. Wet your page, and with your biggest brush, start to paint the major shapes of the underpainting as indicated by your small plan. My painting will develop a warm, sunny feeling. My first delicate washes will be in a range of cool blues to provide relief and contrast to the dominant warmth that will come later. Work quickly to keep these first washes soft and diffused. Without going deeper than middle value, complete the design of your underpainting.*

Step 3. *It is time to decide on your subject. You will find it's easiest to use material that you know well. One of the "character silhouette" studies you did earlier (Chapter 3) might be good for a start. The underpainting has been allowed to dry. Mix up a middle-dark value of your "theme color" (I'm using a burnt sienna) and start the first simplified structure of your subject. Explore linkage from one area to another, and distribute patterns with concern for your total composition.*

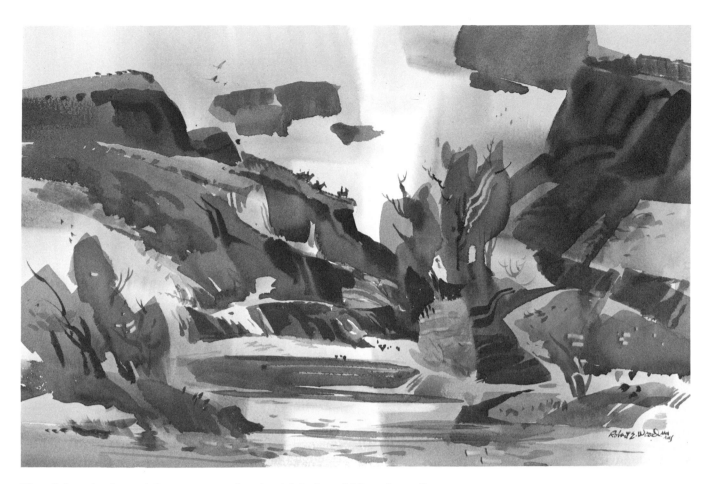

Step 4. *Local color variations can now be struck into the middle-value pattern just established. With richer colors and smaller dark shapes, continue to describe your subject. See if you can't finish the painting with a minimum of refinement and detail. Let this be an understated translation of your subject into symbolic patterns. Now sit back and take a good look at the nearly finished work. See if there are any disturbing sky holes—spots where the underpainting shows through openings in your structural darks. These can be adjusted by painting them with a slight change of color so they are no longer obvious. A second thing to adjust is the edge quality of the bold shapes. Soften an edge of a totally crisp shape now and again so a transition is provided into the softer underpainting.*

One Underpainting–Different Subjects.
I'm including additional examples to
illustrate further just how independent
the underpainting can be.

Completed Underpainting. *D'Arches paper, 13½″ x 20″. Using the small
composition plan as a guide, I painted four half-sheet underpaintings, as nearly
alike as possible. The shapes were painted on a dampened page so they could
be kept soft, and the darks limited to no deeper than middle value. My color
scheme is predominately warm–a range of yellows through ochres and earth
tones with a smaller portion of complementary blues and violets. One of the
finished paintings that resulted is shown on the opposite page.*

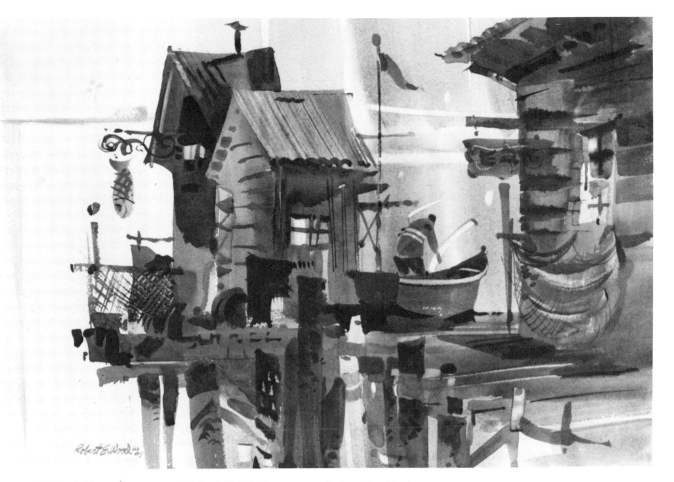

Dead End Wharf. *D'Arches paper, 13½" x 20". Whatever your choice of subject, the goal of the first overpainting phase is to design a well-scaled arrangement of simple shapes in middle and middle-dark values. Pay attention to the total composition, and stay away from finishing things too soon. Let the details wait. Keep the bigger brushes at work, and you will have better results.*

__Wharf Space II.__ D'Arches paper, 13½" x 20". A good example of using overlapping shapes and aerial perspective to create spatial sensations.

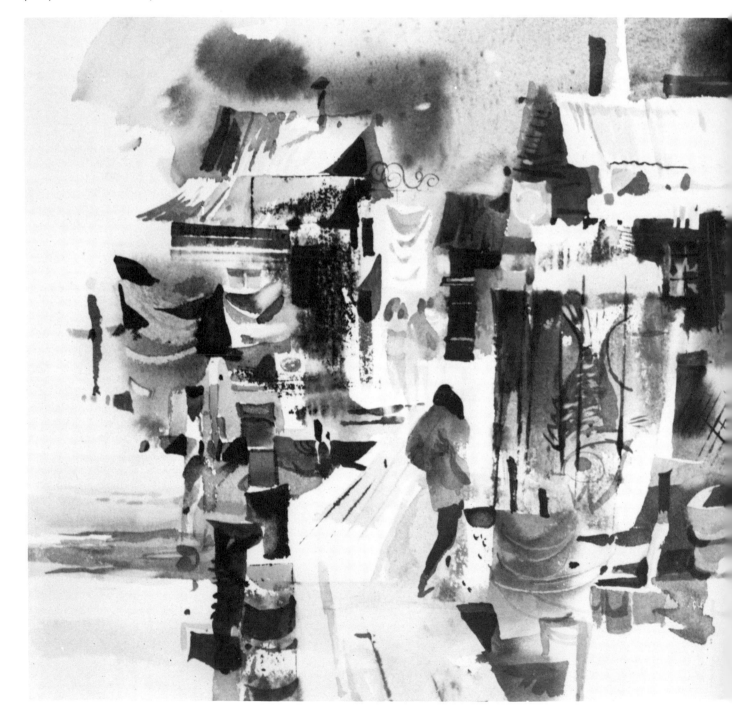

10. Space Concepts

A painter is limited to a flat surface on which to create an illusion of a third dimension —depth in space. Traditional perspective relies on lines that appear to taper or converge in a diminishing manner to a vanishing point on a distant horizon line. This is the method taught in basic drawing classes; you'll remember the classic cubes, cylinders, and spheres you were asked to draw in perspective.

The serious artist needs to understand the principles of linear perspective and how to put them to use in his work. However, there are other methods of building strong spatial sensations that many competent painters seem to be unaware of. In this chapter, some powerful tools for creating a three-dimensional feeling will be presented. A diagrammatic line and wash study will help you explore the theory behind the use of these perspective tools. The painting problem will apply the various concepts almost arbitrarily in a large watercolor—a creative work that makes decisive spatial impressions. Most artists today aren't concerned with the infinite horizon (with the exception, possibly, of those painting in a surrealistic style that benefits from the illusion of limitless space). The comtemporary artist often "tips up" the horizontal surface of his composition so it seems nearer to the picture plane. This develops a feeling of limited depth with many overlapping shapes. There are multiple spatial sensations that appear to happen close to the surface of the page. Several concepts of perspective can be used to project this arbitrary sense of space.

Overlapping Shapes. *This is a clear statement of one object in front of another. The eye level is close to the ground. The effect is one of objects on a tabletop, and no shape has a common border with its neighbor. Shapes are placed so there is either adequate space between objects or an obvious overlap.*

Aerial Perspective. *Here the shapes overlap, but the objects are stepped up the ground plane, not crowded on the horizon line. The effect is one of looking down on the scene. The patterns are distributed effectively throughout the picture and make a clear statement of spaciousness.*

Push Back. *Sometimes referred to as "push-pull," this is based on the idea that dark recedes and light comes forward. By pushing back the space behind objects with a softened halo of a cool dark, the light objects are pulled forward, and feelings of space are enhanced.*

Cast Shadow. *A light source can be a logical, single light, or there can be multiple light sources. Shadow moves along the ground plane and possibly up a neighboring vertical plane. It establishes form and distance between objects. With a multiple light source, shadows can be pushed in various directions to balance the design and distribute the effect of spatial sensations.*

Diminished Repeat. *Objects in space appear to grow smaller in the distance. By repeating an object in several diminishing sizes, the artist creates a sensation of distance.*

Linear Perspective. *I've left linear perspective until last, not because I think it unimportant, but because it is probably already understood. Also, my emphasis is on the other 3-D tools.*

Exercise: Line and Wash Spatial Study

If there is one fact that I can be sure of, it's that *there is no one way to paint a watercolor*. The concepts presented won't provide guaranteed success in your next few paintings, but hopefully they'll open new areas of involvement with your work and offer a source of inspiration that will lead you into new creative experiences.

For this technical exercise, you'll need 18" x 24" work paper, a few dark colors, and a Number 8 brush. Mark off several 9" x 12" areas on your paper, and follow the steps in the accompanying illustrations.

Step 1. *Draw several 9" x 12" picture areas on inexpensive drawing paper. Use your Number 8 brush to draw a subject of your choice. Pick something that will allow you to display many simplified overlapping shapes. Don't worry about doing an accurate finished drawing. Think of the objects as stand-up cardboard cutouts, and distribute them so they develop spatial sensations throughout the total picture area. An aerial perspective view will help in this regard.*

Step 2. *Duplicate your brush drawing in another painting space. To emphasize the feeling of distance between shapes, push back the area of space behind each spot where an overlap occurs. Use a middle value of blue to trim around sections of the forward shapes. Then fade the blue area with a brushstroke of clear water, and it will become just a "halo" of spaciousness. Notice that the white shapes are now pulled forward. This is what is meant by "push-pull." Use a darker blue to invent shadow shapes that can augment the feeling of space between objects. The way the shadows fall can describe the surfaces between areas of subject matter. Let the shadows move in almost any direction. It is more important to balance the spatial sensations than to have a single light source at this time.*

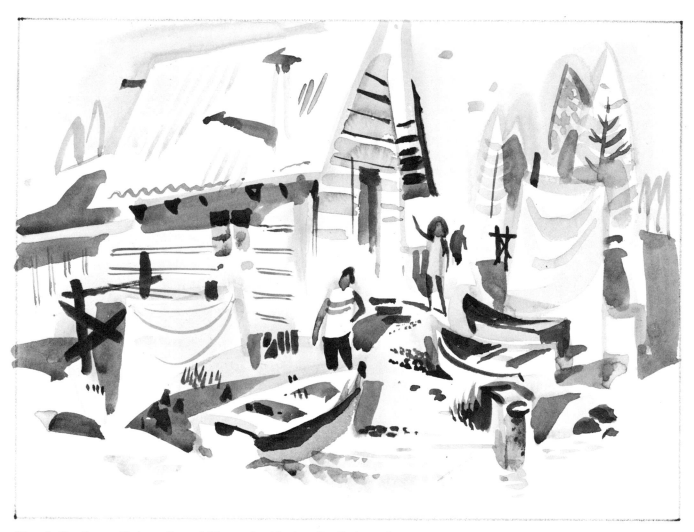

Step 3. .Continue with inventive additions of subject matter that use the diminished repeat *to further enhance the feeling of distance. Use people, boats, or trees in various sizes. Start introducing color to identify different parts of this study. Experiment with* color perspective. *Use some rich warms in the foreground parts; then mix cooler versions and find uses for them deeper in the painting. Pure, intense color will record as something close; gray or neutralize color slightly and you'll see that it recedes.*

Painting Problem: A Statement of Space

It's time to put some spatial tools to work in a full watercolor painting. I suggest you try a full sheet. If you use 300 pound paper, no stretching is necessary. Thinner weight paper will work more effectively if you stretch it ahead of time. My painting is done on an even larger size—d'Arches "double elephant," 26" x 40".

Choose a subject that you've painted before or a made-up composition you can do from memory. Sometimes this latter suggestion works best; you're free to invent, select, and insert things as needed and aren't restricted by too concrete an image. A fully-packed composi-tion works best. Plan a build-up of shapes that allows you to explore spatial effects, the true goal of this painting problem.

Start your painting in the normal "big brush" manner. Search for an abstract display of scaled, simple shapes, and concentrate on spatial sensations as you develop this abstract underpainting. If you can, make the dimensional feelings "pulsate" the page in these early stages; it should be easy to bring the subject into focus later.

After the page is broken up with a variety of overlapping shapes, try your push-back method to increase the ap-pearance of depth. Start while the page is wet for a softness—a halo effect—that can be very pleasing. As the page dries, some spots of push-pull can be reinforced with touches of firmer edges.

Color perspective, di-minished repeats, and cast shadows are the other tools to explore. These tools aren't for-mulas that must be used con-sistently throughout the paint-ing. Trust your instincts and paint with your feelings as you see the page develop. After all, it's just another painting—a painting that offers the chance to experiment with a seasoning of spatial sensations.

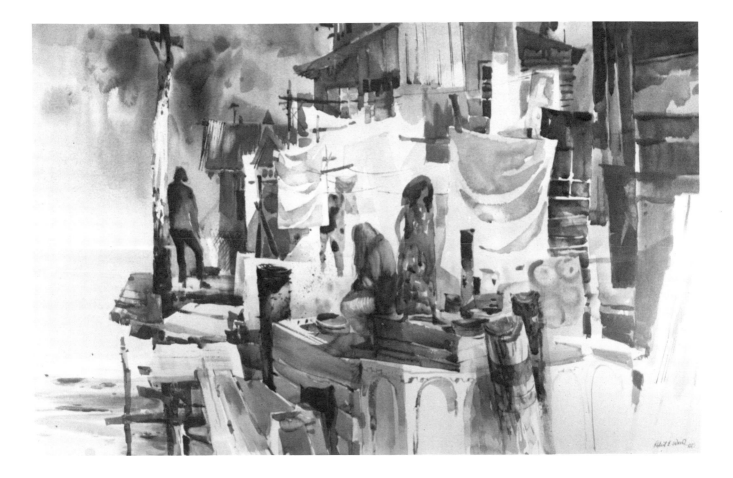

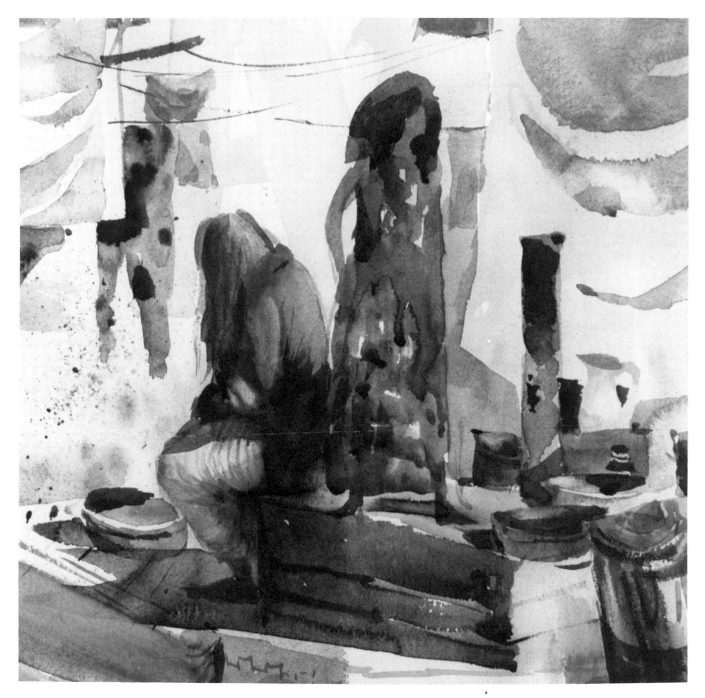

A detail of Tie and Dye People.

Tie and Dye People. *D'Arches paper, 26" x 40". This painting uses the 3-D tools discussed earlier. It was painted immediately after my return from a workshop in Sausalito, California. I had done several paintings on location and had a good number of drawings in my sketchbook. This painting is not a particular place; it's a memory study of the general character of Sausalito. One challenge I set for myself when I started this work was to develop a strong spatial statement, not to record the images of a particular location. For this reason, I felt completely free to "build my own subject" from any of my past experiences and to invent new material if needed.*

A New Composition. *Select one of your paintings to be used as a source for a discovered composition plan. Prepare a variable-sized finder by cutting an old mat into two L's. The three-value study you will be doing in this chapter requires just one tube of dark paint, your large brushes, and inexpensive work paper.*

11.

Painting Within a Painting

I believe in going out to paint from nature—it's my favorite way to discover new things to paint. But when painting on location, I'm tempted by the wealth of material a new subject offers. No matter where I look, there's an overabundance of exciting design, color, and form. More often than not, the temptation is too great, and I try to say too much in a single painting.

The simplification and selective control needed in a good, finished watercolor is easiest to achieve in the studio. There, the fully packed, on-location picture can be reworked. The same basic composition can be recreated in a more dramatic and simplified version, or the original painting can serve as a source for completely new presentations.

How to find new, exciting compositions in a previously-painted work and how to use them as inspiration for fresh, creative paintings will be the goals in this chapter. In the technical exercise the stress is on how to find a new composition within the old one. For the painting problem, you'll make use of your own discovered composition.

SANTANA HIGH SCHOOL LIBRARY

Exercise: A New Composition

Gather together some of your paintings, finished or unfinished, that can be used as source material for three value composition plans. You'll also need an old painting-sized mat that can be cut apart (into two "L's") to be used as a variable-sized viewer. The exercise will be done on 18" x 24" work paper with a single dark color.

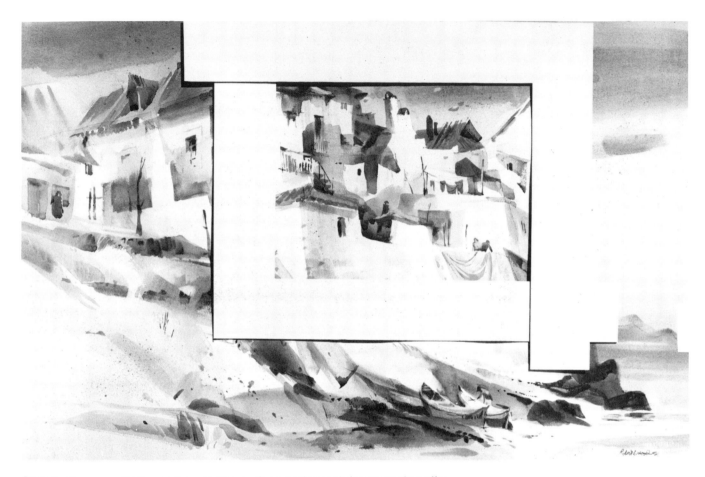

Step 1. *Move your finder on the painting surface and search for areas that offer uncommon spatial balancings and sensations of scale. Try vertical formats as well as horizontal and both large and small dimensions. When you find a composition that you enjoy, fasten the mat with push pins or masking tape. Mark out a rectangle on your work paper, 10" x 14" or larger. If necessary, pencil in the major space divisions of your composition. Then, with a light value, paint over the whole page except for the near white areas. When this is dry, use a middle-value wash and paint in the bulk of the plan. Finally, paint in the dark patterns as suggested by your plan.*

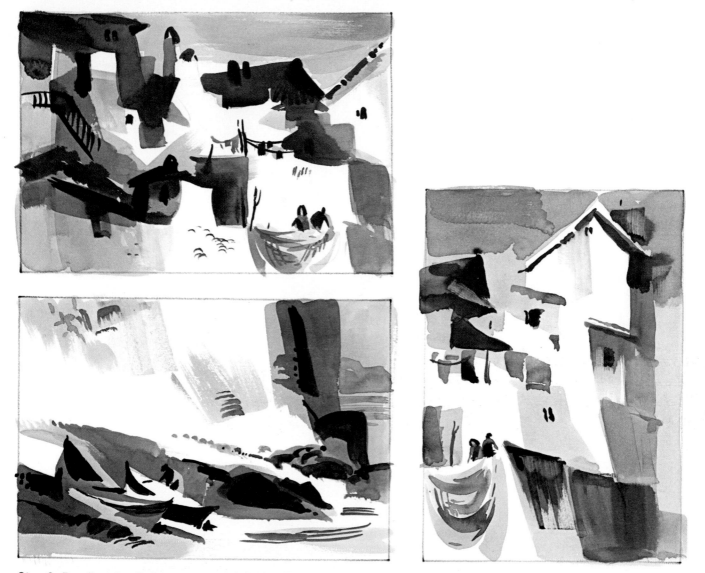

Step 2. *Readjust the finders on your painting until you discover another new composition. Outline another workspace on inexpensive paper and paint this discovered composition in three values. Search for more compositions. In each trial your goals should be to discover interesting distributions of light and dark, a bold sense of scale, and different shape presentations. This is not the time to trim or slightly crop your original—in effect barely refining your first work. This is the time to create new, exciting paintings. Why paint another so-what watercolor?*

Painting Problem: New Paintings from Old

You'll be selecting a portion of a previous painting as a design source for a new work, but the problem will be something more than just rendering a part of another painting. the term "new painting" is the real key; some adjustments will have to be made to complete this painting successfully.

Containment is one aspect that needs to be considered. Because the composition began as a part of something larger, it probably has some patterns and colors that are powerful at the edges. By weakening value contrasts and color intensity near the borders of the page, and by letting some of the edge shapes soften with a wet-into-wet technique, the feeling of containment will be strengthened. The new painting should emit a feeling of completeness.

The color of your new work can take its character from your original, but it too, will most likely need adjusting. If you like the color mood in your original painting, I recommend you copy that as a starting point. As soon as the page is covered with your first major washes (which start to establish the color mood), I think it would be wise to turn your original painting to the wall. Now watch only what is going on in the new painting. Develop a distinctive color quality and balance in this new work. Feel free to place related color accents effectively within the painting.

Some areas may seem too open and uninteresting, so probably will need further description and detail. A more important challenge, however, is to keep the underpainting and middle value stage of the development simple. You may find that the painting you do from your discovered plan will turn out to be as complicated and fully-packed as your original. Remember: K.I.S.S. Try to keep it simple.

And as a last reminder: this is a new and separate painting. The original only furnished a composition plan and color suggestion and should have no further influence. Once the painting is underway, cooperate with it. Trust your emotions, your instincts, and let the evolving shapes and colors lead you into an exciting creation.

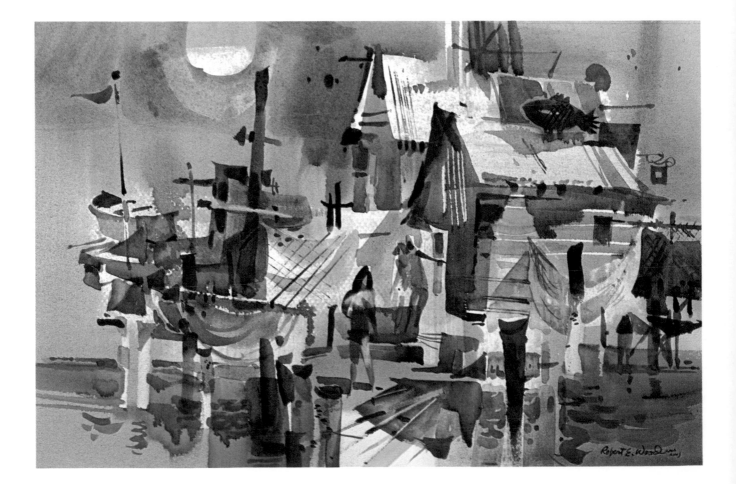

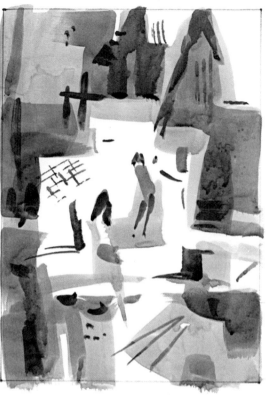

Step 1 *(Left). If you don't want to use one of your plans from the previous exercise, start from the beginning with another painting and select a portion of it for your new composition. Convert it into a small, painted, three-value plan to use as a guide for this painting problem. I'm using* Wharf Scene, *13½" x 20", for this demonstration.*

Step 2. *Here are several ideas for new paintings that were isolated from my original wharf scene. Though all three composition plans were found within the same painting, notice how different each is in its scale and balance and overall gesture. Each one could inspire another painting. I have used the first of the three as a guide for this painting problem.*

Step 3. This will be a half-sheet painting on good watercolor paper, stretched, and will require your full palette of colors. Prop up your painted composition plan and your original painting (with the mat in place) where they can be seen easily. Pencil in the major space divisions of your chosen plan, and get your color controls in mind. Wet your page and start painting the colors and big shapes that surround and capture the light patterns you want to retain. Concentrate on the overall design of your composition and establish a color mood that determines the character of the painting.

Step 4. Before the page dries, strike in the major middle-value patterns as suggested by your value-plan guide. Once these are established, it would be wise to turn your reference material to the wall. Now it's important to work up a finished painting with merits of its own. There are no rules or restrictions from here to the finish. I suggest that you try to keep away from too much detail too soon. Use any technique that seems suitable. If you notice interesting textural variations, spatial qualities, or exciting color feelings developing, by all means make use of them.

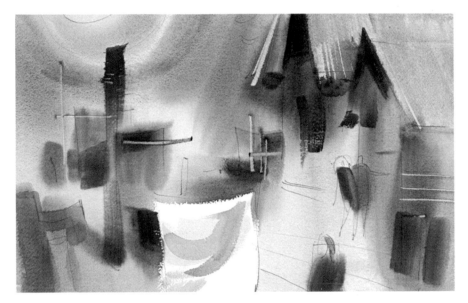

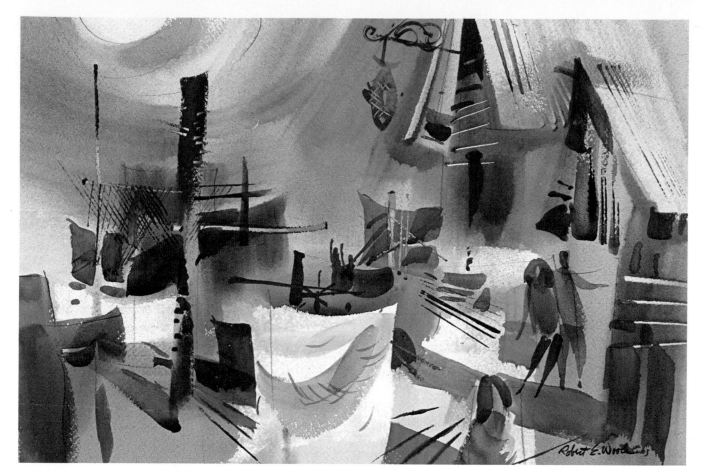

Wharf Scene II. *D'Arches paper, 13½" x 20".*

Beach Figures. *Drawing paper, 18" x 24". The inexpensive drawing paper I used for this study makes it easy to be casual. The paper isn't precious; neither are the drawings.*

12. Figures in Painting

Introducing the human element into your work can add emotional interest, character, and scale to an otherwise bland painting. A landscape painting doesn't need figures in order to make it a vital, finished statement. However, I often enjoy trying to capture man's relationship to nature—his blending into his surroundings or even his awkward contrast to his environment.

How to successfully integrate figures into your paintings will be the major concern of the following material. I won't attempt to deal with the use of the single figure as the main subject in painting, and certainly not portraiture. Those aspects of figure painting have their own specific demands.

Stylistic Control

The most common pitfall when using figures in watercolor painting occurs when the artist in unsure of himself; he tends to leave the people until the end of the painting process and to paint them in a style foreign to the rest of the subject matter. The practicing watercolorist usually arrives at a point where he can translate nature (trees, clouds, fields, water) into expressive shorthand statements. He creates a suggestion of objects instead of rendering things in complete detail. When he inserts figurative interest, however, he begins to illustrate in a different manner. The resulting figures look like an afterthought (which they are) and loom off the page with an unfortunate degree of importance.

Figures in paintings have psychological attraction. An equally bold and colorful inanimate object will be definitely subordinate to a spot of human interest. People in paintings have the ability to attract and hold our attention. For this reason alone it's worth exploring ways to blend figures into the overall design construction and almost camouflage them within the other elements of composition. The technical exercise will suggest ways to handle figures in a fresh, symbolic, and painterly way. The painting problem will relate to methods of integrating human interest with the design concept that has established the rest of the painting.

Sketchbook Rewards

Once again I'd like to emphasize the importance of acquiring the sketchbook habit. The awkwardness of figures in paintings is often the result of simply not knowing the subject well enough. After all, you can only paint what you know. There is no way to overstress the importance of continued practice in drawing, sketching, and painting figures. It's essential to be completely familiar with sketching figures in order to paint them with simple freshness and directness. Models are plentiful. If you use your spare moments to do quick sketches of the human activity around you, painting the figure will be increasingly less fearsome.

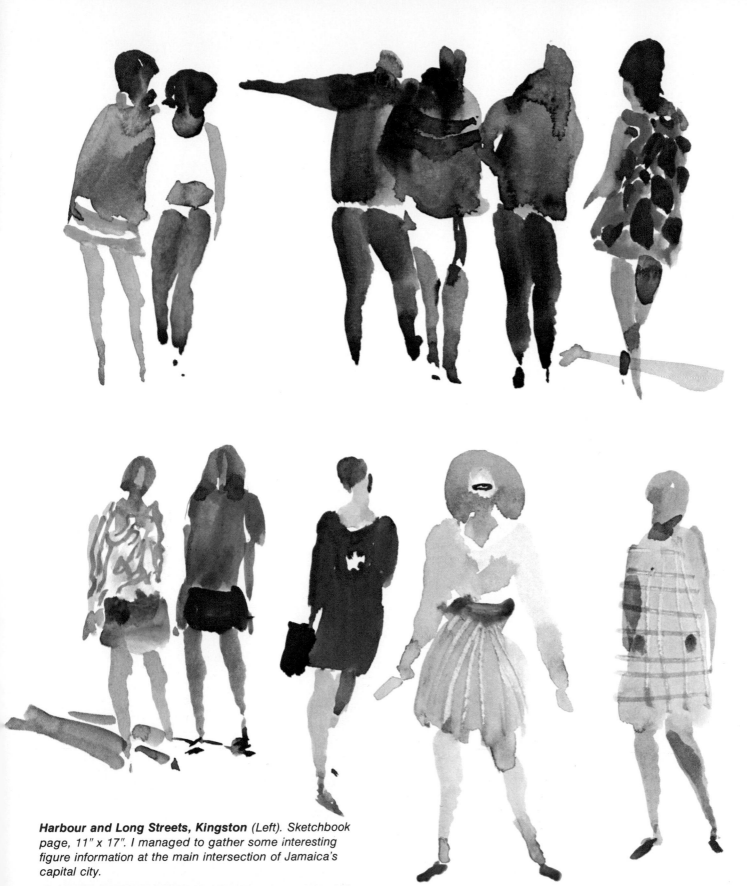

Harbour and Long Streets, Kingston *(Left). Sketchbook page, 11" x 17". I managed to gather some interesting figure information at the main intersection of Jamaica's capital city.*

Shopping Center Sketches *(Above). Drawing paper, 18" x 24". These people strolling through a large shopping center were seen for just a few seconds. Each instant impression was recorded with the fewest number of brushstrokes; then another passing model was observed and painted.*

Exercise:
Brush Sketching

The artist who wants to incorporate the figure in his paintings must learn to translate the human form into shapes, colors, and masses instead of outlines. To do this, there is no substitute for brush drawing. The fluid property of pigment and water lends itself to a painterly result—one that will blend into a watercolor as an intrinsic part of the whole.

Unfortunately, the physical situation of sketching in public often limits the artist to pens or pencil for quick line studies. It will be necessary for our purpose that you find a location where you can observe groups of people and still set up your equipment (a small palette, three or four colors, a Number 8 brush, and a water container) and work directly with your painting tools. A comfortable working situation might be in your home using family members as models, or you might try looking out a window. A beach or a park also offers a good variety of subjects. It's important to learn to look intently—to understand what the figure is doing—and then work quickly in an attempt to capture the essential shape of your figure or figure groups.

This exercise can be done either on sketchbook pages or the larger 18" x 24" work paper. Color isn't a demanding part of this problem, but if you have a full palette you can experiment with different combinations of pigments that suggest a variety of flesh qualities. Paint figures of varying sizes and try out your pointed brushes—anything from your Number 6 to your Number 12.

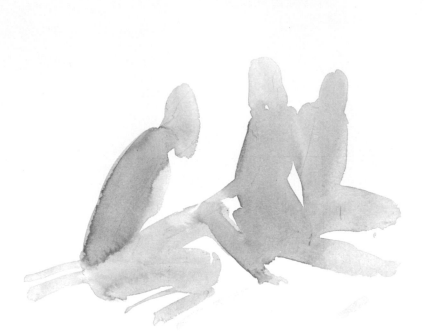

Step 1. *To start, mix up a middle-light value of a warm flesh tone. This can be almost any mixture of yellows, oranges, and reds. I'm using yellow ochre and bright red (vermilion) to establish the massive structure of the whole figure group. The subjects are painted without outlines. Try to capture the overall shape of the subject–to suggest mass and weight. Work directly with the one simple color and search out unified figure silhouettes.*

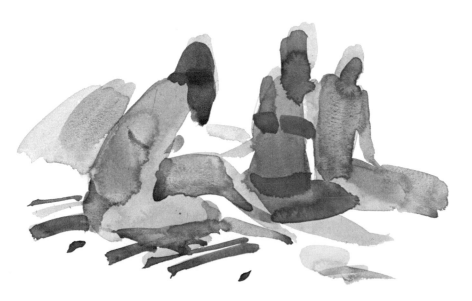

Step 2. *Darker flesh tones can be used to* push back *different segments of the figure. A variety of local color shapes can be introduced to start the suggestion of other parts of your composition. Stay away from outlines as you introduce clothes, cast shadows, and other pieces of your study. The middle-value structure should develop without insignificant details. It is actually better if adjoining pieces touch and run together than to have a design with too many isolated compartments.*

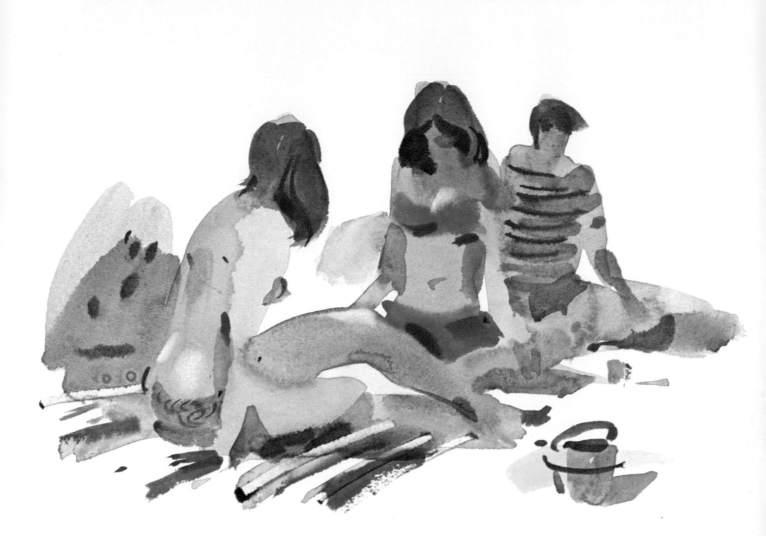

Step 3. *This study should not be overworked. The goal is to put down some figurative interest in a painterly, symbolic way–one that could eventually work well with other freely painted parts of a finished painting. Use your middle-darks and darks to finish this study. Before the shadowed parts of your figures dry completely, touch in a little cool blue to make them recede. Mingle a hint of warmth (reflected light) into your cool cast shadows. Add a limited amount of small color accents and rich dark shapes to further describe your subject.*

Painting Problem: Starting with the Abstract

Earlier chapters have explored the abstract underpainting approach to starting a painting. It allows a free and easy adjustment of scale, color balance, and design unity. Nonobjective elements of the composition are well conceived before the subject is introduced. The same approach can be practiced when the figure is involved. The figure should be thought of as a shape or a color, a piece of the whole rather than a separate specific element unlike the rest of the painting.

One firm suggestion that will prevent the figures in your painting from being obvious afterthoughts is a simple one: don't wait until the end of the painting process to start developing the figures. Touch in a simple shape or two of color early in the painting that will indicate where the human interest is to be developed. In the middle stages, carry the figures to a half-finished state. When the rest of the work is in a final stage of adjustment, the figures won't be a struggle and will seem to almost complete themselves.

Discovering figures within a nonobjective display of shapes and colors will be the game played in this painting problem. Your aim is to practice designing figures that will integrate well with the basic design concept of the painting. Full equipment, full palette, and the large sheets of work paper will again be needed.

Step 1. *Paint an arbitrary arrangement of overlapping rectangles that are light to middle values and are primarily a range of warm tones (yellows to reds). The control of scale (emphatic large, middle-sized, and small units) and balance are the first goals. Immediately introduce a smaller, dispersed amount of cool colors. These should not be too dark and could repeat the casual blockish theme.*

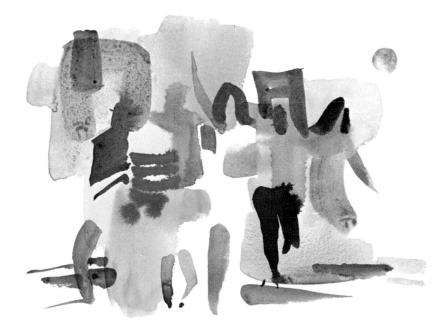

Step 2. *Use middle value and darker colors to start breaking into the underpainting with shapes that give a first hint of figures. Develop some body masses by painting in their shapes (or cutting around to make them exist). Support some of these masses with a variety of tapering leg shapes, and design further interest with head gestures and arm movements. Don't finish things. Distribute the* hit and miss *structural indications about the composition.*

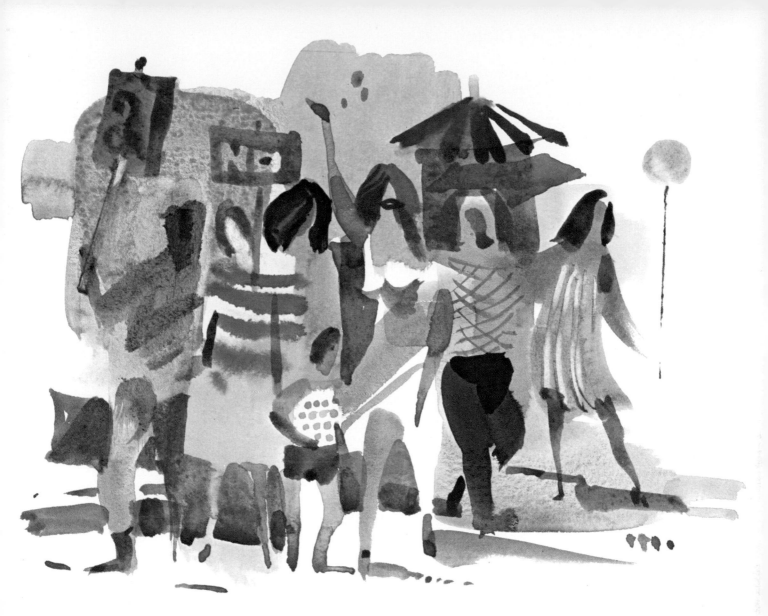

Step 3. *You can be as inventive as you like in finishing this figure group. Add clothes, umbrellas, shadows, bags, signs, balloons, etc., to distribute decoration and description around the composition. Use color to spark up the display and further control the balance of the overall arrangement. Don't be concerned with what to paint as you finish this exercise; it's more important to know* what not to *paint. Let this study stay purposefully unfinished in some of its parts. Let the figures retain some of the lost-and-found quality that will provide a needed transition between subjective description and abstract organization.*

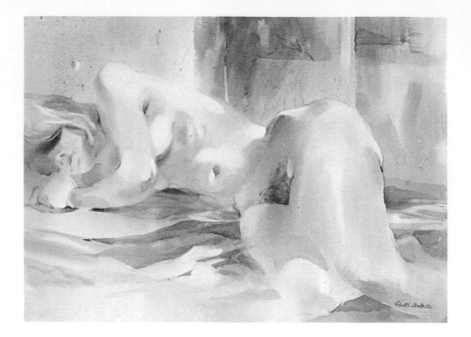

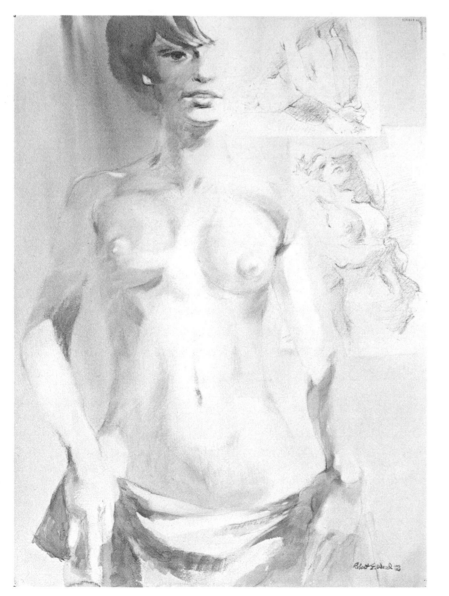

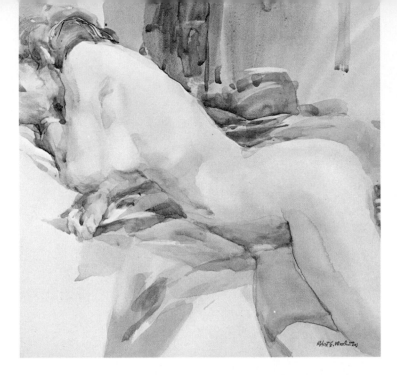

Nude 4 *(Left). Bristol paper, 15" x 15".*
Warm Slumber *(Below). D'Arches paper, 26" x 40".*
Sleeping Model *(Far Left). D'Arches paper, 22" x 30".*
Mimi *(Below Left). D'Arches paper, 22" x 30".*

These paintings are examples of using the figure as the main subject in a composition. I usually do these paintings in my studio from finished charcoal drawings done directly from the model. I also often use charcoal to do a direct drawing on the watercolor paper before painting.

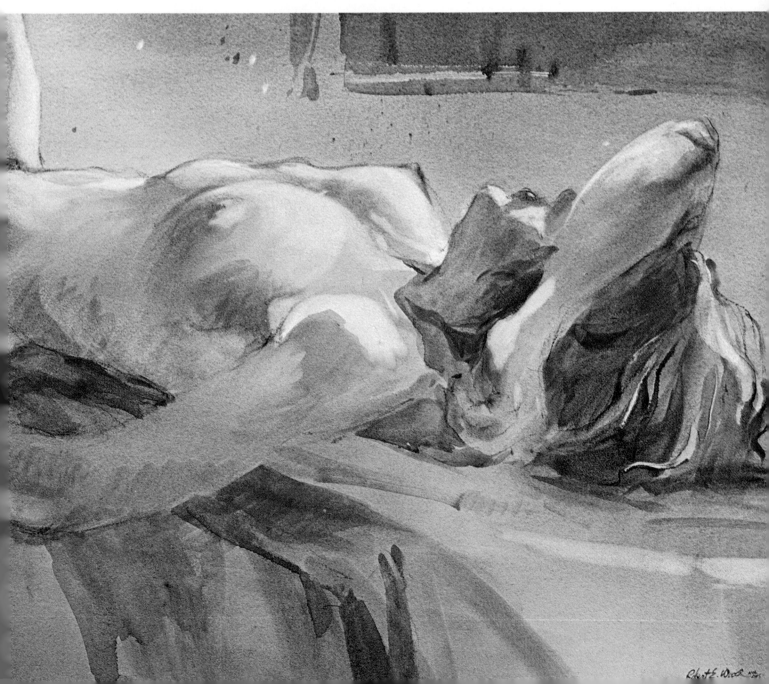

Deep Creek. *D'Arches paper, 22" x 30". This painting is a result of years of gathering information by painting and sketching in my home environment. The boldly distilled statement happened only after I had painted and repainted this same theme; by then I had developed my own ways of working that allowed me to translate nature into authoritative watercolor symbols.*

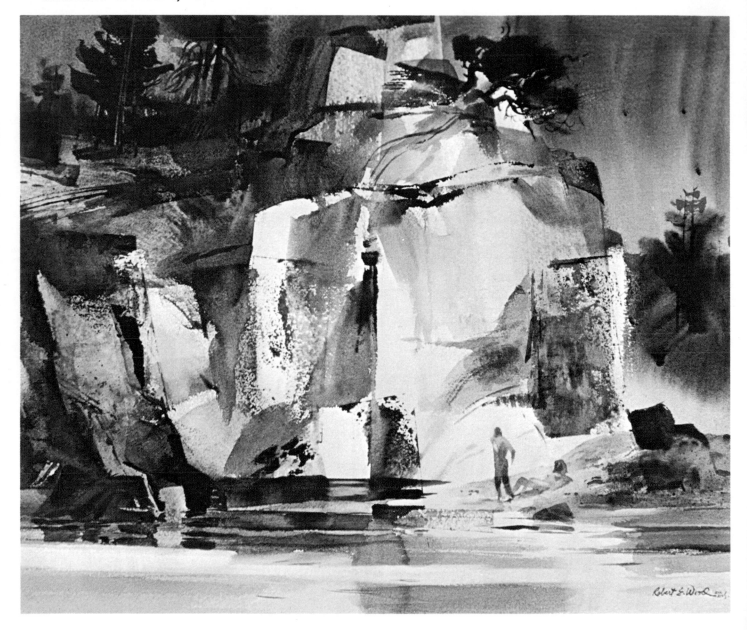

13.

Theme and Variations

I can't even remember when I started painting in the California mountains, but I've lived beside a mountain lake for the past 16 years in a home I originally built as a vacation cabin. The trees, cliffs, lake, and cabin are subjects that have appeared in literally hundreds of my paintings. Rather than getting tired of my surroundings, I continually find more things around me to paint. It seems that the better I know a subject the more intriguing it becomes. Other favorite subjects of mine are the seashore, wharves, or an old barn. I find it stimulating to return to these old friends again and again. There is always something new to say about them in a painting.

A familiar subject painted often in fresh ways could be called a *theme and variations*. In this chapter, the theme is cliffs and trees. From sketchbook and worksheet pages to finished paintings, I'll show the steps in my thinking while I develop different presentations of one subject.

Although my first contact with this subject is long in the past, I've continued to gather information through drawings and paintings—and by observing the changing seasons and moods nearby. Most of the work included here was done within the last several years. The choice is deliberate. I want to show that the familiar subject can still be approached creatively—that there are endless reasons for painting another watercolor.

At times an artist shares his experience in a teaching situation by presenting his goals and his methods of reaching them. This is practical and valid, but watercolor painting can't really be boiled down to a formula. It's learned by doing. My advice is to digest any and all suggestions that make sense—and then rely on your training, background, instincts, and emotions. Believe in yourself and paint to your own satisfaction. Let me wind up this chapter with the one rule I subscribe to: where creative painting is concerned, *there are no rules!*

The following illustrations are actual studies and paintings. They were not done as lesson plans with a specific, predetermined goal. They are just creative paintings—work done with a free, searching attitude. In the captions that accompany the paintings I'll attempt to point out my personal application of the watercolor tools and techniques that have been examined step-by-step throughout the book.

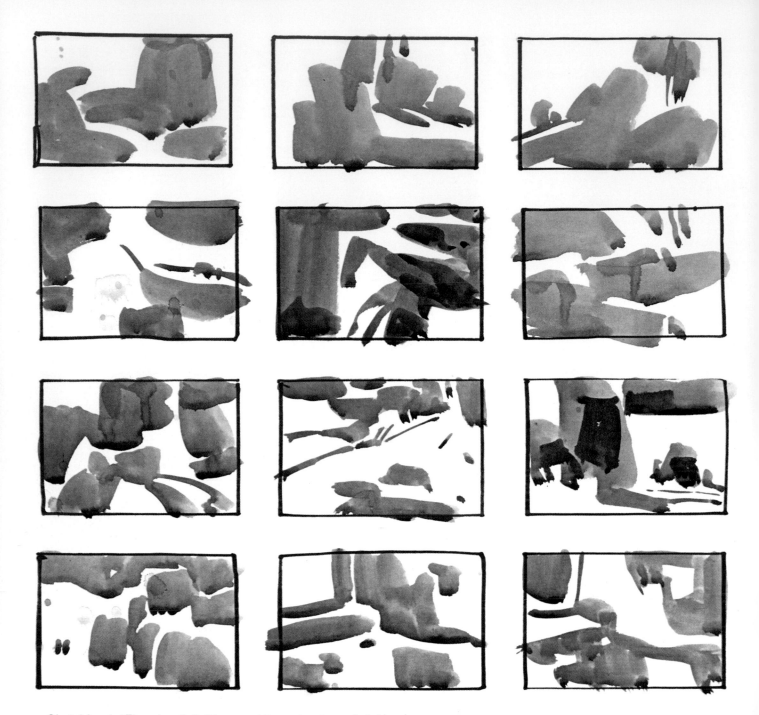

Sketchbook "Thumbnails". *Dispersed throughout my sketchbooks are many sketches such as these. Once I know my subject, the question is not "what to paint" but "how can I best present the material?" The small composition plan can help you think out the possible relationships between scale, balance, and containment.*

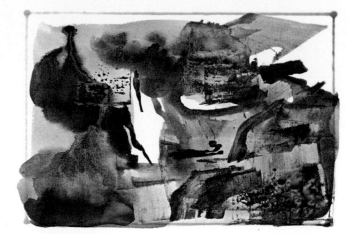

Basic Composition Plans. *Another means of arriving at a dramatic presentation of any given subject is the simplified value study. Doing many of these brush studies forces me into inventing unusual compositions. It's only so much work to go on and paint the final painting; why not start with an exciting plan?*

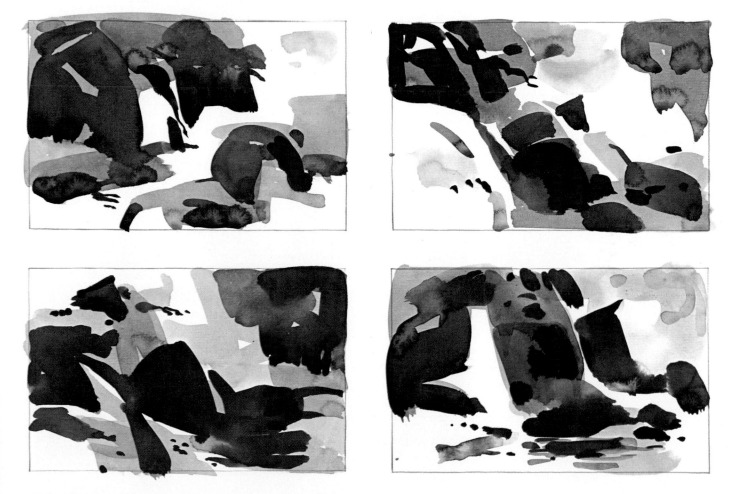

Value Studies. *These slightly larger thumbnails explore the possibilities of various textural qualities as well as dramatic compositional ideas. An anything goes attitude is important for these experiments. If one special plan out of ten stimulates a new painting, the time is well spent.*

Full Painting Explorations. *D'Arches paper, 22" x 30" and 13½" x 20". It's difficult to enlarge small sketches into free and vital large paintings without considerable practice. After I develop a plan for guidance, I need to do a series of large paintings in order to approach the final work with the same freedom and directness that made the smaller preliminary studies effective. Three of the full-sheet studies shown here immediately preceded painting* Deep Creek. *You can see that the stream doesn't exist in these compositions; it was "discovered" in the later painting. To plan a work is important, but it's also important to cooperate with what happens on the page and to let* creative involvement *lead you into developing a new statement. The moonlit scene is a half-sheet painting and uses a majority of deep values for its* dramatic staging

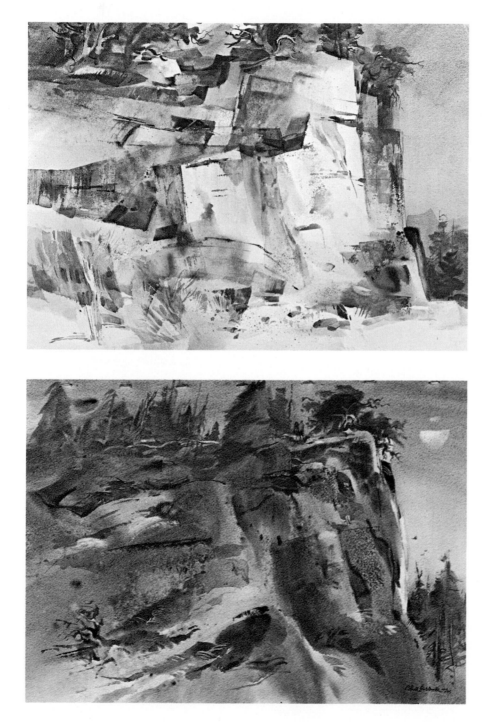

Return in Winter (Top Left). D'Arches paper, 26" x 40". This clearly shows the vitality a watercolor can have when it concentrates on the symbolic translation of subject matter into brushstrokes, textures, and clusters of patterns instead of reporting every possible detail. The underpainting provides a passage from one object to another. Some scaled lights were saved. Other means of regaining the lights, such as squeegee strokes with cardboard scraps and with the brush handle (snow on the trees) were also used. Textural variations were achieved by brush spatter, stampings, and the granular wash.

Dunn's River Falls (Bottom Left). D'Arches paper, 22" x 30". The brushstroke patterns of the figures show that they were painted with the same freedom as the rest of the subject. I introduced the first bold estimate of the bathers early in the painting process. Some refinements were added in the finishing stages, but I took care not to overwork them. I tried to retain the same symbolic character that is displayed in the direct handling of the trees, rocks, and water.

A Walk into the Clouds (Bottom Right). D'Arches paper, 26" x 40". As the seasons change my surroundings provide new impressions, new moods, and new reasons to paint a familiar subject again. I remember the exact moment that inspired this painting. I was driving out of our valley in newly fallen snow, and the clouds were shifting the focus on various parts of the landscape. Trees and ridges would loom forth and then disappear. When I returned to the studio I did this large watercolor in the glaze and character silhouette method. The scene isn't a rendering of a definite place, but I certainly was influenced by and tried to capture the essential character of my general surroundings.

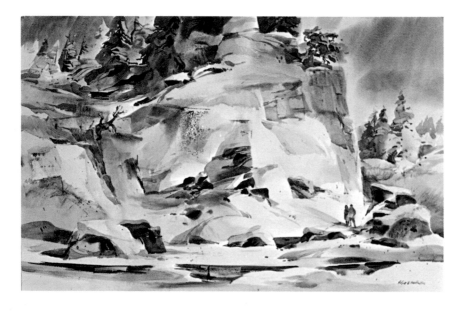

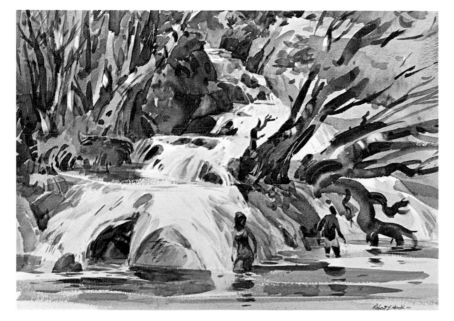

Empty Rendezvous *(Right). D'Arches paper, 26" x 40". The same inventive scene as* Return in Winter *is shown here with a different mood prevailing. The more rounded shapes create a slow dynamic design theme. Wet-into-wet handling is used more extensively and causes the dominant softness in shapes and textural qualities. Color can also contribute to a definite mood or feeling. While this painting was predominantly warm, the winter scene was just the opposite.*

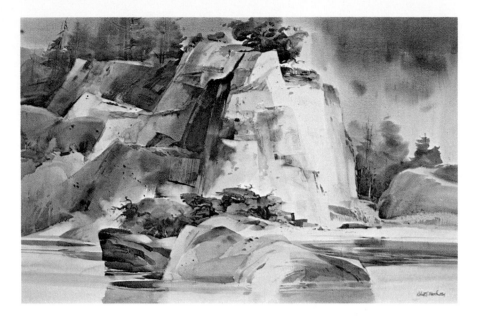

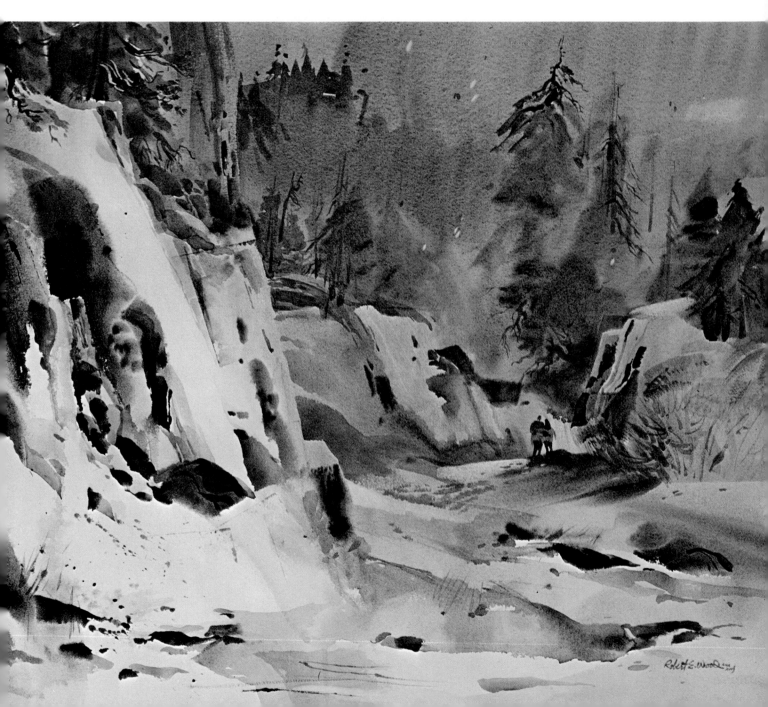

Robert E. Wood:
A Profile
of the Artist

by Mary Carroll Nelson

Patty. D'Arches paper, 22" x 30". I prefer working directly from the model, but I'm sometimes forced to take photographs instead. In this case, I knew the model well and was able to make good use of photographic reference material. I did large finished drawings first to develop an awareness of structure problems and establish an interesting composition. The more you know about your subject ahead of time, the better. It's a bit rough to wonder how a figure is constructed in the middle of a wet-into-wet battle.

SANTANA HIGH SCHOOL
LIBRARY

Robert E. Wood.
Photograph of the artist by Maurice Roy.

Robert E. Wood is a watercolorist, specifically a California watercolorist. Given the same talent in a different spot, the chances of his art developing just as it has are nil. His early teachers—Millard Sheets, Milford Zornes, and Phil Dike—are names associated with the California school of watercolor. There is no such place, of course, as "The California Watercolor School." It's a term applied to the line of painters that began back about 1925 with such men as Barse Miller, actually a New Englander, and descended through Sheets, Dike, Rex Brandt, George Post, Dong Kingman, plus many others, and now includes Robert E. Wood as a member of the third generation of the school.

Being a Californian is a whole thing in itself. It's a style; it's a philosophy. Sun, pine-covered mountains, desert, golden hills, ocean, snow, boats, color —they surround the artist with limitless possibilities. The Californian lives in a vacation paradise yearned for by those in harsher climates. Some Californians don't realize the potential. Jaded as they are by too many people, freeways, and smog, they no longer see the glittering world around

them. Robert E. Wood still sees California as the Golden State and responds to it with his personal *joie de vivre*.

There are traits that the whole California group of watercolorists have in common. They delight in the transparency and fluidity of the medium. When they began painting, a long distance in time and space separated them from the salons of the East. The watercolorists painted splashing, free-flowing, bold suggestions that had the zing and glow they saw around them. Lush washes, sparkling whites, calligraphy, and powerful design were applied to paintings that reflected the multifaceted California geography of sea, desert, ranchland, and mountain. An Oriental restraint was combined with a western daring in a manner distinctively Californian.

The California painters resisted the precisely rendered wash and line landscapes of the Royal Watercolor tradition from Great Britain. They painted, invented, taught, and passed on their discoveries. As the years went by, a California look was created.

There is an iconography associated with California. There is the sun painted as an orb, a circle within circles. There are

alphabetical signs, whole or partial, and hanging draperies suspended here and there as the composition dictates. Sometimes there are spots and spatters. The simplest looking brushstrokes take on, deftly, the texture of rocks, sand, or waves. The whole style is an exercise in superb control, an invention in shorthand, with a new perspective all its own.

Robert E. Wood grew into this tradition. He inherited through his teachers, locale, and absorptive talent the whole dynamic amalgam of impulse and style that means watercolor on the West Coast. A Wood painting is infused with his energy and zest. Beneath the power of its color, the delight of its brushwork, and the surprise in detail, there is a sound abstraction, the intellectual design of which Wood is a master.

The white of the paper is sacred treasure in a watercolor, hoarded by the artist. Wood's command of whites takes in the saved white and also the lifted-out white with a technical expertise that is deep and unprejudiced. He uses whatever works to achieve an effect, creatively experimenting to contrast value and color. Pigment, water, brush, and paper are amplified by Wood to in-

clude matboard pieces, tissues, blotters, stamping materials (such as cork and leaves), a piece of screen and a toothbrush, atomizers, or anything that presents itself to apply pigment to paper. Wood absolutely dominates his medium. He long ago passed the level of expert and arrived at the level Rex Brandt describes as the poetic or creative level—the Nirvana of artists.

Robert E. Wood (Bob) was born in Gardena, California, on February 4, 1926. He was educated in the public schools of Los Angeles through high school. He studied and apprenticed briefly as a commercial artist before he enlisted in the Air Corps in 1944. Release from service led to further schooling. He graduated from Pomona College in Claremont, California in 1950 and remained as a graduate student, completing his Master of Fine Arts degree in 1952. He and his wife, Joni, were married in 1950.

After teaching three years at the University of Minnesota in Duluth, Bob took Joni on a protracted trip to Europe in 1955. For eleven months he painted steadily on the island of Ischia. These months of sustained effort convinced Bob that he wanted to be a fulltime artist

rather than a fulltime teacher. The Woods came home to California and moved to Green Valley Lake. They now have a daughter, Stacey, and a son, Darien.

The Wood home was originally a vacation cabin built by Bob. It now houses his home, gallery, office, and his school, opened in 1961. The school is one of the largest enterprises in the tiny village. Green Valley Lake is a good place to live. In winter, it's a ski resort with ski instruction available from Bob Wood. In summer, it's a fisherman's vacation resort. At 7,000 feet, it's above the smog line. The area provides a wealth of subject matter for Wood's paintings. Rustic cabins are surrounded by towering pines. Vacationers, swimmers, and skiers are the live models Wood captures in his omnipresent sketchbook. Cliffs and rocks abound along the roads. These outcroppings have inspired a series of paintings.

Less than two hours away lies the coast of California, whose beaches have been familiar to Bob Wood since childhood. Among his best-known subjects are the wharf scenes created from his storehouse of remembered images, fresh sketches, and im-

agination. Vibrant, crowded paintings of overlapping shanties, signs, figures, boats, and pilings are painted by Wood in a kaleidoscopic variety of color and mood. The wharf is the subject in many of his award-winning watercolors.

The artist's choice of medium has much to do with his inner nature and the private view of the world he needs to express. Watercolor, traditionally, is an optimistic, affirmative artform chosen by those, particularly in America, who exult in their land and the beauty they see around them. Wood has this positiveness in his personality. The visual world is his inspiration. He repeatedly returns to nature for information-gathering in the form of sketches, large brush drawings, and small watercolor plans. From these he begins to create paintings, not renderings of particular places, but expressive responses to reality. His times for study—collecting visual memories—are periods for ingesting the forms and details that characterize the places he has seen. Once he has investigated and recorded a spot, he owns it artistically. New England, Jamaica, Mexico, Portugal, and Morocco are as much a part of his repertoire as California.

Wood paints with authority, using these subjects as a reference. His paintings have a tendency to become part of a series. His earliest versions of a subject have more attachment to locale and specifics. As he does more variations on a theme he becomes increasingly abstract. In painting a watercolor, Wood begins with an abstraction—a design in color and value, well-structured, that forms the underpainting. He then adds just enough subject matter to give content to his painting. A totally nonobjective painting does not appeal to him as a goal: a totally realistic work would be repellent to his style. "I believe a watercolor can have two different lives," he says. "From a distance, I like it to be soundly structural, a logical statement. Up close it becomes beautiful pieces of brushstroke, color, and texture—an identity. I have a love for these little pieces of abstraction."

A Wood painting has certain distinctions that mark it as his. Shapes are often lifted out as light areas, roughly rectangular, although one side is usually softened. Shapes don't coincide with edges but have a life of their own separate from subject matter. Edges are lost and found. Color is dominantly warm or cool, but is always balanced by some of its opposite. There is a "now you see it, now you don't" sense of mystery in his most intriguing work. Contrasts are essential in his approach to design. Velvety wetness is accented by the crispness of a sharp edge. Dynamic diagonals are relieved by some static areas. Wood always balances elements.

Although Wood's art has not undergone a major change in style over the years, it has become more abstract, and subject matter has taken on the aspect of a key needed only to unlock the abstraction. He widens his knowledge of nature as he grows. Study is one of his self-disciplines, but he gets freer all the time from the limitations of natural appearances. If there is any way to determine a chronology to Wood's art, it would have to be in the area of invention. The more he paints, the more he invents.

Wood intellectualizes painting. His greatest feat occurs before he does anything at all to his paper, during the planning stage. Technique is no problem to him at all; he can achieve any effect he has planned. There is a possibility, of course, that technical wizardry

can become a problem for an artist and could lead to empty glibness. Wood recognizes this problem. To surmount his own ease with the brush and every conceivable watercolor approach, Wood spends much of his time inventing the hardest problems he can. To solve problems creatively is his aim. Highly competitive, his biggest challenge is to compete with his own work, striving toward ever more difficult painting feats.

Wood enters the toughest shows with his best work in California, at Watercolor USA in Springfield, Missouri, and in New York. Watercolors by Robert E. Wood have been winning awards in top shows since 1958. In the world of professional watercolorists, his work has merited two major distinctions for him. He became a member of the American Watercolor Society in 1967 and was elected a vice president of the Society in 1970. In 1971, he was voted into the National Academy of Design as an associate member.

During a part of every year, Wood shares his knowledge by teaching, in his own school for five weeks each summer, on "Painting Holidays" to distant places, and in workshops he conducts throughout the country. Wood teaches through demonstrations. He shares his creative process with his students from first sketch to finished painting. Each demonstration is prepared by planning, but once he's on the spot before an audience, he relies on pure, spontaneous, creative instinct to develop his plan and carry it through to the painting he has in mind. He paints at a rapid pace, talking now and again as he works. The whole experience of watching him is to see a virtuoso in the act of using his instruments.

A demonstration by Wood is an unforgettable experience esthetically and kinesthetically. It resembles an athletic event or a ballet with Wood filling the role of performer. A description of one of his demonstrations captures a glimpse of this active man who builds up his subject from an abstract design to finished painting with a flourish and speed that leaves the viewer breathless.

The demonstration begins with Wood making little plans to get in the mood. "I want to think symbolically rather than of things," he says. "More paintings are lost in this stage than in the finishing touches." He makes many thumbnail plans, some rectangular, some with arabesques—each is different, but each has a suggestion of form, a statement of space. "I'm not too much a linear painter," he explains, "but I like to paint spaces."

From his plans, he chooses one with an aerial perspective, with many things in front overlapping things in back. He decides to push back with cool and dark shapes. He staples his 300 pound sheet directly on the board. He plans to do a hot painting, with colors orchestrated to set a mood. He explains his ideas as he works.

Wood wets his sheet down with clean water and a dirty brush. He begins laying on blue shapes—slight, squarish ones on a vertical grid. He adds yellow-green, some orange, some red. Most of the sheet is painted out, with a limited amount of saved white. He turns the board upside down and keeps adding bright and bluish reds, using the flat brush very fast. His board is tipped slightly at an angle. He's thinking about color and rectangular shapes, but not about subject matter. "Nothing is near middle value yet," he says. "So any of these shapes can be dominated by a darker, bolder tone."

He puts some torn blotters down and leaves them on the painting. Then he scrapes some lights out with matboard pieces while the blotters remain on the sheet. He paints stripes on a matboard scrap, stamps it on the picture, and leaves it there. He adds small darker values around the big, open forms. Now he removes the blotters and matboard. There are shack roofs, one with old boards on it. He lifts out a moon with a brush, letting it hover below a deep mauve slash of what now appears to be sky. A form resembling a sheet seems to be draping from an unseen wire.

"The challenge here is not, 'can I turn this into wharf, boats, and signs,' but 'can I continue to organize it?'" he tells the crowd. "Every part of this painting is not equally precious. There will be parts I want to accent more, and other parts I'll be painting will be more delicate." So saying, Wood begins to add details. A roof now appears corrugated from brushwork. A little fence is made with the edge of a matboard scrap by stamping it in pigment and then onto the sheet.

The painting is basically red, but there are other colors for contrast. Wood explains, "Color isn't rich when it's all pure. Cool and warm mix underneath to mute it. Small bits of pure color enrich it." He varies the red subtly to give the sky its own character as opposed to the water.

More details are added to the wharf—a ladder, a cluster of figures, a white post-squeegeed out with the brush handle, all done with lightning speed and dexterity. When he paints, Wood moves, stepping back, forward, bringing his left wrist to steady his right hand for a precise stroke, then resting his left arm behind his back, wiping his brush, swishing it in water, in paint, on the paper in vigorous gestures —short, snapping ones like a tennis player whacking a ball.

Wood looks up a moment and says, "In my studio, I would stop at this stage and stand back to look at it. I've done the rapid type of painting I believe in. It has the organization I want. I'm painting faster than I can consciously consider, relying on the emotional judgment and coordination of hand and eye that has developed through years and years of painting."

Wood returns to the battle. He uses mat pieces as a stencil and sponges an area clean. He paints in a figure, a small deck, a roof area. Then, he looks at the work in a demonstration frame. The painting has a lost and found quality in every shape. Like the Navajo rug-weaver who always leaves a pathway for evil spirits to get out of her designs, Wood has left a way for the eye to get out of each shape. Things vary from sharp to vague. There are no continuous lines enwrapping a form. The red wharf is nearly complete. If there is more to do, he will do it alone when he can study the painting. It's a statement of space, busy, but not nervous space, lit by a dying sunset and a rising moon. The mood is peaceful in spite of its hot colors. Much is left to the imagination. "I try to tell it without telling it all," the artist concludes.

A careful focus proves that one cannot describe or explain the scene. What shadows that portion of a boat? What brightens that sheet that seems to be hanging there? What shopkeeper hung that fish sign from its curlicue of iron so high above the buildings? What sea embraces this rosy wharf?

We aren't supposed to know these answers. We are to feast our eyes first on the pattern of light against dark. We are to

enjoy the details for their own sake. We can well ask if Wood gives us more than we need to see of a place, or less? His statements delight; they tell us about the scene, but they aren't full accounts. They are, rather, a group of notes spun together in a rhythm. The rhythm is the reaction of the artist to his theme. It's meant to cause a similar reaction in the viewer. We respond to the arc of a stroke, to the splash of a spatter, to the energy of the work.

For Wood, the audience itself has been a catalyst. "I work best under pressure. The adrenaline flows—something happens." He practices by planning ahead, but once on view he goes into a mental gear somewhere just a little above the conscious. He calls on his ability and all his experience for his performance. The most obvious clue to the effect of the audience on the painter is in what he says while he paints. Words come easily, in brief epigrammatic sentences or flowing paragraphs. He is always articulate, but he is at his best on his own subject, watercolor painting, when he is doing it.

At this demonstration, in a little more than an hour (plus 25 years of preparation) Wood has created a work of art. During the act of painting, Wood let the watercolor develop itself, working with an attitude of discovery so he could capitalize on any spontaneous happenings. It's in knowing when to leave the plan behind and allow the painting to occur that Wood shows his mastery.

This is how Robert E. Wood is today. A compact, in-shape man, a human dynamo of creative potential, he approaches each new painting as the challenge of the moment. With a purely Californian bravado, he is sure that anything is possible and looks forward to an increasingly harder contest with himself; one he is determined to win.

Biography
and Awards

Robert E. Wood, A.N.A., A.W.S. Born in California and educated at Pomona College, B.A., Claremont Graduate School, M.F.A.; Vice-President of the American Watercolor Society; Associate of the National Academy of Design; Member of California National Watercolor Society; Watercolor West, West Coast Watercolor Society, Southwestern Watercolor Society, San Bernadino Art Association, Redlands Art Association, and Laguna Beach Art Association.

Since 1961, director of Robert E. Wood Summer School Of Painting, Green Valley Lake, California. Also taught at University of Minnesota, Otis Art Institute, Scripps College, Claremont Graduate School, Riverside Art Center, and the Rex Brandt Summer School.

Traveling Workshops

Featured instructor on Painting Holiday workshop tours to Spain, Portugal, Jamaica, Mexico, Morocco, New England, France, and Tahiti. Conducts private workshop classes and lecture-demonstrations throughout the United States, including:

Arizona: Tucson

California: Bakersfield, Cambria Pines, China Lake, Fresno, Long Beach, Los Angeles, Monterey, Oxnard, Palm Springs, Redlands, Riverside, San Bernadino, San Diego, San Fernando, San Jose, Santa Ana, Santa Barbara, Santa Maria, and Sausalito

Colorado: Denver, Golden, Greeley

Idaho: Twin Falls

Kansas: Wichita

Nevada: Las Vegas

New Mexico: Albuquerque, Los Alamos

Oklahoma: Oklahoma City, Tulsa

Texas: Dallas, Houston, Lubbock, Rockport

Washington: Tacoma

Wyoming: Casper, Cheyenne, Sheridan

One-Man Exhibitions

1968-70. The Gallery, Palm Springs, California

1968-69. Cheyenne Artists Guild, Cheyenne, Wyoming

1968. Salem Gallery, Salem, Oregon

1969-70. The Zachary Waller Gallery, La Cienega, Los Angeles, California

1969. Neusteters Gallery, Denver, Colorado

1970-71. The Brandywine Gallery, Albuquerque, New Mexico

1972. The Jones Gallery, La Jolla, California

1972. The Red Ridge Museum, Oklahoma City, Oklahoma

1973. Le Nid Galerie, Northport, New York

1973. Wichita Art Association, Wichita, Kansas

1973. The Brandywine Gallery, Albuquerque, New Mexico

1974. Camelback Gallery, Scottsdale, Arizona

1974. Las Vegas Art Museum, Las Vegas, Nevada

1974. Griswolds Gallery, Claremont, California

Also: Phyllis Lucas Gallery, New York; Walker Art Gallery, Minneapolis, Minnesota; Gallery Blu di Prussia, Naples, Italy; Soligen Ohligs, Germany; Margot Schiffman Gallery, Hesperia, California; Ken Merrill Gallery, Newport Beach, California; Scripps College, Claremont, California; Westown Gallery, Westwood, California; Galleria del Monte, Montecito, Santa Barbara, California; Gallery One-Eight-Five, Pasadena, California

Watercolor Awards

1958. *California Watercolor Society:* Duncan, Vail Co. Award

1958. *1st Annual Claremont Arts Fair:* First Purchase Award

1961. *All California Invitational:* Laguana Beach Festival of Art. First Prize Watercolor

1961. *All California Art Exhibition:* National Orange Show, San Bernadino. First Prize Watercolor

1963. *Watercolor U.S.A.:* Springfield Art Museum. Purchase Award

1963. *California Watercolor Society:* Ted Gibson Award

1964. *California Watercolor Society:* Lytton Financial Corporation. Purchase Award

1964. *All California Art Exhibition:* 49th National Orange Show. First Purchase Award

1966. *Watercolor U.S.A.:* Springfield Art Museum, Lytton Savings and Loan. Purchase Award

1966. *Butler Institute of American Art:* Youngstown, Ohio. Fine American Art Calendar Purchase Award

1967. *All California Art Exhibit:* 52nd National Orange Show. Watercolor Prize

1967. *Inland Empire Art Exhibit:* San Bernadino Art Association, California. Second Award— First Watercolor

1967. *Butler Institute of American Art:* Youngstown, Ohio. Museum Purchase Award

1968. *California National Watercolor Society:* The Watercolor U.S.A. Award

1968-69. *Inland Exhibition III and IV*

1969. *American Watercolor Society:* The John Younger-Hunter Memorial Award

1970. *All California Exhibition:* National Orange Show. First Award

1970. *Second Annual Watercolor West Exhibition:* Third Award

1970. *Wichita Centennial National Exhibition:* Purchase Award

1970. *Inland VI Exhibition:* San Bernardino, California. First Purchase Award

1970. *California National Watercolor Society:* Bruggers Award

1971. *American Watercolor Society:* New York. The Martha T. McKinnon Award

1971. *Watercolor West III:* Riverside, California. Third Award

1971. *Southern Cal Exposition:* Del Mar. First Award Watercolor

1971. *Redlands Many Media Mini Exhibition:* Second Award

1972. *Watercolor U.S.A.* Springfield Art Museum. Purchase Award

1972. *Watercolor West:* C.N.W.C.S. Award

1973. *Riverside XI Annual:* Purchase Award

1973. *Watercolor West:* C.N.W.C.S. Award

1973. *All California Exhibition:* National Orange Show. Third Award

1973. *California National Watercolor Society* Members Exhibition: C.N.W.C.S. award

1973. *Southern California Exhibition:* Del Mar. Second Award

1973. *California National Watercolor Society Annual:* Buzza Award

1974. *Watercolor West:* First Award

Publications

The Watercolor Page: American Artist Magazine, summer 1968

The Search for a Creative Watercolor: Forty 35mm color slides with accompanying narration by the artist

Painting Credits

Index